KINGS OF THE NORTH

Photographs and History of the Minnesota Vikings

by
Chad Israelson

LAKE7
CREATIVE

Minneapolis, Minnesota

Acknowledgments: I would like to thank Ryan Jacobson and Lake 7 Creative, LLC. Also, John and Shirley Hogan for letting their house become Vikings Central virtually every fall Sunday. —Chad Israelson

Edited by Ryan Jacobson
Proofread by Emily Beaumont
Fact-checked by Natalie Fowler
Cover logo, player sketches, and background garnish by Shane Nitzsche
Interior design by Ryan Jacobson and Shane Nitzsche

Chuck Foreman photograph (front cover) by uncredited photographer. Copyright 2021 The Associated Press. Colorization by max_edits. Football photograph (back cover) by Billion Photos/Shutterstock.com. For additional photography credits, see pages 174–175.

The information presented here is accurate to the best of our knowledge. However, the information is not guaranteed. It is solely the reader's responsibility to verify the information before relying upon it.

This book is not affiliated with, authorized, endorsed, or sponsored by the National Football League, its players, or anyone involved with the league.

The use of any trademarks is for identification and reference purposes only and does not imply any association with the trademark holder.

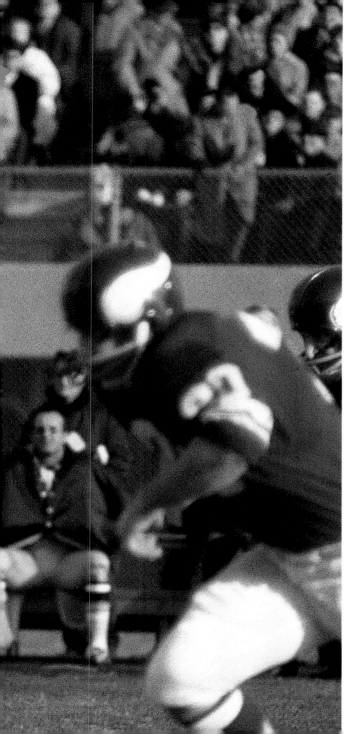

The Scrambler

Fran Tarkenton revolutionized the position of quarterback in the NFL, while simultaneously earning the wrath of head coach Norm Van Brocklin, by scrambling (or running around with the football). This radical approach garnered him nicknames like "the Scrambler."

Between 1961 and 1966 (when the Vikings traded him to the New York Giants), Tarkenton began his journey into the NFL record books for passing—and he also rushed for 1,893 yards. The scrambling signal caller would make two Pro Bowls in that span, an honor he shared with offensive mates like linemen Grady Alderman, Milt Sunde, and Mick Tingelhoff; receivers Paul Flatley and Jerry Reichow; and running backs Bill Brown, Tommy Mason, and Hugh McElhenny.

As an expansion team, the Vikings took a few years to surround their star quarterback with talent to match his own. From 1961 to 1967, the Vikings posted just one winning season, going 8–5–1 in 1964.

Still, with Tarkenton at quarterback, they were an exciting product to watch as they marched toward their future greatness.

5-8-1
Fourth Place (tie)

The 1963 season indicated that the Vikings' fortunes were on the ascent. They matched their combined win total from the previous two campaigns, and the year proved notable for individual accomplishments.

Running back Tommy Mason became the Vikings' first All-Pro, and receiver Paul Flatley's 51 receptions helped him win Rookie of the Year honors. Tackle Grady Alderman and linebacker Rip Hawkins joined Mason as starters on the Pro Bowl team.

During 1963, the Vikings notched a 34–31 win versus the Detroit Lions, their first-ever against the future division rival. It was a game that should not have been played. NFL commissioner Pete Rozelle made the controversial decision (one he later said that he regretted) to go forward with games that weekend, despite President John F. Kennedy's assassination two days earlier. The Vikings and Lions played at Metropolitan Stadium under the pall of the terrible events, and many players claimed that it was one of the most difficult games of their careers. The contest itself was a seesaw affair. The Vikings rallied in the second half with a Tarkenton touchdown pass to tight end Gordon Smith and a touchdown run from Tommy Mason that sealed the victory.

Minnesota also tied the eventual-NFL-champion Bears, 17–17. However, the 56 points yielded to the Saint Louis Cardinals were the most ever given up by a Vikings defense.

The team added kicking great Fred Cox to the roster (after cutting him in training camp the year before). However, they missed out on former Minnesota Gopher and future hall-of-famer Bobby Bell. The Vikings chose him in the NFL draft, but the Kansas City Chiefs picked him in the AFL draft. Bell opted to sign with Kansas City.

As a team, the Vikings made the NFL record books by causing opponents to fumble 50 times and by recovering 31 opponent fumbles.

The team's talent base was evident with the three-win improvement over the prior season.

Schedule

	OPPONENT	SCORE	RECORD
W	@ San Francisco 49ers	24–20	1–0
	Chicago Bears	7–28	1–1
W	San Francisco 49ers	45–14	2–1
L	St. Louis Cardinals	14–56	2–2
L	Green Bay Packers	28–37	2–3
L	@ Los Angeles Rams	24–27	2–4
L	@ Detroit Lions	10–28	2–5
W	Los Angeles Rams	21–13	3–5
L	@ Green Bay Packers	7–28	3–6
L	Baltimore Colts	34–37	3–7
W	Detroit Lions	34–31	4–7
T	@ Chicago Bears	17–17	4–7–1
L	@ Baltimore Colts	10–41	4–8–1
W	@ Philadelphia Eagles	34–13	5–8–1

Season Leaders

CATEGORY	TOTAL	PLAYER
Passing Yards	2,311	Fran Tarkenton
Rushing Yards	763	Tommy Mason
Receiving Yards	867	Paul Flatley
Receptions	51	Paul Flatley
Interceptions	5	Ed Sharockman
Sacks	10.5	Marshall/Hultz
Points	75	Fred Cox

Key Additions:
Fred Cox (free agent)
Paul Flatley (draft)

Starting Lineup

Gene Washington 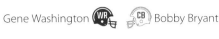 WR | CB Bobby Bryant

Grady Alderman LT | DE Jim Marshall

Dave Osborn RB

LB Wally Hilgenberg

Jim Vellone LG | DT Alan Page

SS Karl Kassulke

Joe Kapp QB | Mick Tingelhoff C

LB Lonnie Warwick

FS Paul Krause

Milt Sunde RG | DT Gary Larsen

Bill Brown RB

LB Roy Winston

Doug Davis RT | DE Carl Eller

John Beasley TE

K Fred Cox
KR Clint Jones
P Bob Lee
PR Charlie West

John Henderson WR | CB Earsell Mackbee

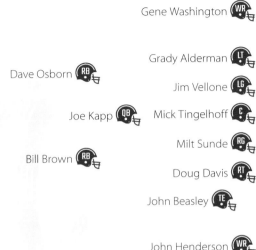
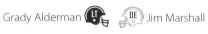

Pro Bowl Selections

- Grady Alderman (T)
- Carl Eller (DE)
- Joe Kapp (QB)
- Paul Krause (S)
- Gary Larsen (DT)
- Jim Marshall (DE)
- Alan Page (DT)
- Mick Tingelhoff (C)
- Gene Washington (WR)

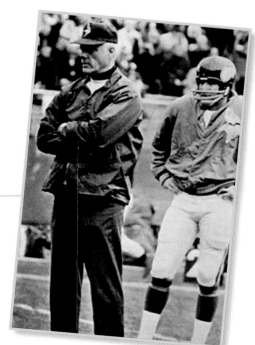

Bud Grant coached the Vikings for 18 seasons.

All-1960s Offense

QUARTERBACK: Fran Tarkenton (1961–1966). Tarkenton started 77 games in the 1960s, compiling 113 touchdowns and 14,579 yards passing. He also earned two Pro Bowl nominations in his first stint as a Viking.

RUNNING BACKS: Bill Brown (1962–1969) and Tommy Mason (1961–1966). Brown easily earned his spot with 4,787 yards rushing, 43 touchdowns, and four Pro Bowls. He added 227 receptions, 2,573 receiving yards, and 16 receiving touchdowns—nine of them coming in 1964, when he led the squad in receptions and receiving yards. Mason, the Vikings' first-ever draft choice, compiled 3,252 yards and 28 touchdowns on the ground. He made three Pro Bowls and was named All-Pro once. Twice, he paced the team in rushing yards, and he led in receiving yards once. Mason hauled in 151 catches in his Vikings career.

WIDE RECEIVERS: Paul Flatley (1963–1967) and Gene Washington (1967–1969). Flatley started 63 games and amassed 3,222 yards on 202 receptions. He led the Vikings in receptions and receiving yards three times, and he earned a spot in the Pro Bowl in 1966. The second spot was a difficult choice between Jerry Reichow and Gene Washington. Reichow compiled better statistics with 144 catches for 2,183 yards versus Washington's 98 catches and 1,961 yards. Both players led their squads in receptions twice, and Washington led in receiving yards three times to Reichow's one. Reichow started more games, and each player earned a Pro Bowl berth. Washington was the more accomplished player, but he split his Vikings career over two decades. He earned All-Pro in 1969 and won this spot by a narrow margin.

TIGHT END: Gordon Smith (1961–1965). Smith nudged out John Beasley for this spot, as his entire career was contained in the 1960s. Smith posted 57 catches and an average of 22.4 yards per catch, which is an astounding total for a tight end—and the best mark in Vikings history for any player with more than 50 catches. Beasley warranted consideration, but he split his time between the 1960s and 1970s.

CENTER: Mick Tingelhoff (1962–1969). Tingelhoff moved into the starting lineup his rookie year and never relinquished it. During the decade, he made six Pro Bowls and five All-Pro teams, and he started 112 games.

GUARDS: Milt Sunde (1964–1969) and Larry Bowie (1962–1968). Sunde arrived as a 20th-round pick and became the Vikings' best guard of the decade. He started 60 games and earned a spot on the 1966 Pro Bowl roster. Bowie topped Sunde's total by starting 72 games at right guard during the decade.

TACKLES: Grady Alderman (1961–1969) and Errol Linden (1962–1965). Alderman arrived via the expansion draft and went on to an illustrious career, with six Pro Bowls, one All-Pro season, and 125 games started. Some fans would perhaps expect Ron Yary to appear here, but Linden started 43 games in the 1960s (after arriving from the Lions) to Yary's six.

KICKER: Fred Cox (1963–1969). Cox began his 15-year run as the Vikings' kicker in 1963. He tallied 665 points in the '60s and led the league in scoring with 121 points in 1969.

KICK RETURNER: Clint Jones (1967–1969). Jones, who also saw action at running back, returned 46 kicks with a 23.9-yard average and one touchdown.

—Data and statistics are for this decade only, unless otherwise noted.—

All-1960s Defense

DEFENSIVE ENDS: Carl Eller (1964–1969) and Jim Marshall (1961–1969). Eller started all but one game during his tenure in the decade, led the team in sacks in 1969 with 15, and earned Pro Bowl and All-Pro honors in 1968 and 1969. Marshall started every game the Vikings played during the decade. He led the team in sacks five times outright and shared the team lead once. He made the Pro Bowl in 1968 and 1969.

DEFENSIVE TACKLES: Alan Page (1967–1969) and Gary Larsen (1965–1969). It did not take long for Page to establish his greatness. He led the team in sacks in his rookie year of 1967 with 8.5. The following year, he led the team in tackles (96) and sacks (11). Although Paul Dickson played the entire decade and started more games (79 to 54), Larsen had a Pro Bowl season in 1969 and was a more integral part of the great late-1960s teams.

LINEBACKERS: Roy Winston (1962–1969), Rip Hawkins (1961–1965), and Lonnie Warwick (1965–1969). Winston, a fourth-round draft pick, started 87 games and intercepted seven passes. The franchise's first-ever second-round choice, Hawkins led the Vikings in tackles for the team's first four seasons, intercepted 12 passes, and earned a Pro Bowl berth in 1963. The hard-nosed Warwick started 61 games, picked off eight passes, and led the team in tackles three times.

CORNERBACKS: Ed Sharockman (1961–1969) and Earsell Mackbee (1965–1969). Sharockman, a sure-tackling corner, made 96 starts and intercepted 27 passes, leading the team in that category for three seasons. Mackbee played the entirety of his career in the 1960s, tallying 60 starts and 15 interceptions. He led the Vikings in picks in 1967.

SAFETIES: Karl Kassulke (1963–1969) and Paul Krause (1968–1969). No safety started more games than Kassulke, with 78. He added 12 picks and eight fumble recoveries. The Vikings had a revolving door at the position next to Kassulke before trading for Krause. Although he only played in Minnesota for two years of the decade, he made a significant impact by intercepting 12 passes and making the Pro Bowl in 1969.

PUNTER: Bobby Walden (1964–1967). As a rookie, Walden led the NFL with 46.4 yards per punt. His 70-yard boot in 1966 was the longest in the NFL that season. He finished his stint in Minnesota with an average of 42.9 yards per punt.

PUNT RETURNER: Charlie West (1968–1969). West took back a punt for a franchise-record 98-yard touchdown in 1968. He averaged 7.6 yards per return over two seasons.

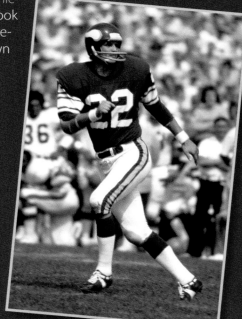

Paul Krause joined the Vikings in 1968.

12–2
First Place

The Vikings entered the season with high expectations. They exacted revenge for the previous Super Bowl loss with a 27–10 drubbing of the Chiefs on opening day.

Minnesota posted an excellent record again, spearheaded by a defense that gave up only 14 touchdowns all season, an average of one per game. During the 1970 season, the Purple Gang posted two shutouts, added two more games in which they surrendered a mere field goal, and in one contest held their opponent to a lone touchdown.

Quarterback Joe Kapp left for the Patriots following a contract dispute, so Gary Cuozzo took over signal-calling duties, playing in 12 games. Although Kapp was never the greatest passer, the team missed his leadership, toughness, and spark to the offense.

Despite Kapp's absence, the streaky offensive squad sometimes scored in bunches. The Cowboys would become one of Minnesota's archrivals during the 1970s, but their first match of the decade proved to be no contest. In a year that the Cowboys went on to represent the NFC in Super Bowl V, Minnesota destroyed them, 54–13. (To date, this total remains the Vikings' record for most in a game). The Cowboys actually started the scoring with a field goal, and early in the second quarter, the Vikings only held a 14–6 advantage. But cornerback Ed Sharockman had a huge day, scoring on a blocked punt and on an interception return in the first half, helping the Purple stake a 34–6 halftime lead. The Vikings continued to dominate after intermission, running their lead to 54–6 before the Cowboys scored a late touchdown. Oddly enough, Dallas outgained the Vikings in total yards, 286 to 258.

The 1970 season ended abruptly in the opening round of the playoffs. The San Francisco 49ers braved the harsh Minnesota winter, with temperatures in the single digits, and upset the turnover-prone Vikings, at Met Stadium, 17–14. The Vikings offense did not score until one second remained in the contest.

All-Pro honors went to Carl Eller, Alan Page, and Mick Tingelhoff. Pro Bowlers also included Fred Cox, Karl Kassulke, Gary Larsen, and Dave Osborn.

Schedule

OPPONENT	SCORE	RECORD
W Kansas City Chiefs	27–10	1–0
W New Orleans Saints	26–0	2–0
@ Green Bay Packers	10–13	2–1
W @ Chicago Bears	24–0	3–1
W Dallas Cowboys	54–13	4–1
W Los Angeles Rams	13–3	5–1
W @ Detroit Lions	30–17	6–1
W @ Washington	19–10	7–1
W Detroit Lions	24–20	8–1
W Green Bay Packers	10–3	9–1
@ New York Jets	10–20	9–2
W Chicago Bears	16–13	10–2
W @ New England Patriots	35–14	11–2
W @ Atlanta Falcons	37–7	12–2
San Francisco 49ers	14–17	0–1

Season Leaders

CATEGORY	TOTAL	PLAYER
Passing Yards	1,720	Gary Cuozzo
Rushing Yards	681	Dave Osborn
Receiving Yards	702	Gene Washington
Receptions	44	Gene Washington
Interceptions	7	Ed Sharockman
Sacks	13	Carl Eller
Points	125	Fred Cox

Key Additions:
Stu Voigt (draft)

Starting Lineup

Ahmad Rashad Nate Allen

Chuck Foreman

Steve Riley Jim Marshall

Charles Goodrum Wally Hilgenberg

Fran Tarkenton Mick Tingelhoff Alan Page Jeff Wright

Jeff Siemon

Ed White Doug Sutherland Paul Krause

Brent McClanahan Matt Blair

Ron Yary Carl Eller

Stu Voigt

K Fred Cox
KR Leonard Willis
P Neil Clabo
PR Leonard Willis

Sammy White Nate Wright

Pro Bowl Selections

- Bobby Bryant (CB)
- Chuck Foreman (RB)
- Alan Page (DT)
- Jeff Siemon (LB)
- Fran Tarkenton (QB)
- Ed White (G)
- Sammy White (WR)
- Ron Yary (T)

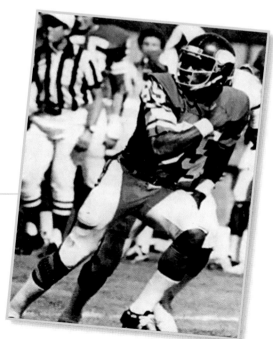

*Sammy White was named to
Pro Bowls in his first two seasons.*

49

9–5
First Place (tie)

Despite winning the NFC Central in 1977, cracks began to show in this powerhouse team. Unfortunately, one of them was in Fran Tarkenton's leg. In Week 9, during a 42–10 win over Cincinnati, Gary Burley sacked the heretofore durable quarterback, and Tarkenton broke his leg. He was lost for the remainder of the season.

After Tarkenton's injury, veteran Bob Lee took over at quarterback. In the first game following the injury, the Vikings defense yielded an NFL-record 275 rushing yards to the Bears' legendary running back, Walter Payton. The Vikings lost the game, 10–7.

In Lee's third game as the starter, the Vikings fell behind San Francisco, 24–0, in the third quarter. This set the stage for the biggest comeback in franchise history. After Lee managed one score, Bud Grant sent in a replacement quarterback: first-round draft pick Tommy Kramer. The rookie rallied the Vikings to a dramatic 28–27 victory with three touchdown strikes, including a 69-yard bomb to Sammy White in the final minute.

In the season finale, the Vikings traveled to Detroit for a Saturday contest. The Vikings' star receivers, White and Ahmad Rashad, each scored. Chuck Foreman rushed for two touchdowns. Eddie Payton kept Detroit in the game by returning both a kickoff and a punt for touchdowns. However, the Vikings beat the Lions, 30–21. With the win, Minnesota captured the division title (despite a season with a minus-18 turnover differential) on a tiebreaker over the Bears.

Instead of hosting a first-round playoff game, the Vikings had to travel to Los Angeles to play the favored Rams. In what became known as the Mud Bowl, the Vikings held on for a 14–7 win. (See page 52.)

The following week, Minnesota's magic vanished. They lost, 23–6, to the Cowboys in the NFC Championship, marking their fourth appearance in that game in five seasons.

Matt Blair, Chuck Foreman, Jeff Siemon, Ed White, Sammy White, and Ron Yary all made the Pro Bowl roster.

Schedule

OPPONENT	SCORE	RECORD
Dallas Cowboys (OT)	10–16	0–1
W @ Tampa Bay Buccaneers	9–3	1–1
W Green Bay Packers	19–7	2–1
W Detroit Lions	14–7	3–1
W Chicago Bears (OT)	22–16	4–1
L @ Los Angeles Rams	3–35	4–2
W @ Atlanta Falcons	14–7	5–2
L St. Louis Cardinals	7–27	5–3
W Cincinnati Bengals	42–10	6–3
L @ Chicago Bears	7–10	6–4
W @ Green Bay Packers	13–6	7–4
W San Francisco 49ers	28–27	8–4
L @ Oakland Raiders	13–35	8–5
W @ Detroit Lions	30–21	9–5
W @ *Los Angeles Rams*	*14–7*	*1–0*
L @ *Dallas Cowboys*	*6–23*	*1–1*

Season Leaders

CATEGORY	TOTAL	PLAYER
Passing Yards	1,734	Fran Tarkenton
Rushing Yards	1,112	Chuck Foreman
Receiving Yards	760	Sammy White
Receptions	51	Ahmad Rashad
Interceptions	4	Bobby Bryant
Sacks	15	Carl Eller
Points	54	Foreman/White

Key Additions:
Tom Hannon (draft), Tommy Kramer (draft), Scott Studwell (draft), Dennis Swilley (draft)

Starting Lineup

Ahmad Rashad (WR) — (CB) Bobby Bryant

Steve Riley (LT) — (DE) Jim Marshall

Chuck Foreman (RB)

Charles Goodrum (LG) — (DT) Alan Page

(LB) Fred McNeill

Fran Tarkenton (QB) — Mick Tingelhoff (C)

(LB) Jeff Siemon

(SS) Jeff Wright

Ed White (RG) — (DT) Doug Sutherland

Brent McClanahan (RB)

(LB) Matt Blair

(FS) Paul Krause

Ron Yary (RT) — (DE) Carl Eller

Stu Voigt (TE)

K Fred Cox
KR Manfred Moore
P Neil Clabo
PR Manfred Moore

Sammy White (WR) — (CB) Nate Wright

Pro Bowl Selections

- Matt Blair (LB)
- Chuck Foreman (RB)
- Jeff Siemon (LB)
- Ed White (G)
- Sammy White (WR)
- Ron Yary (T)

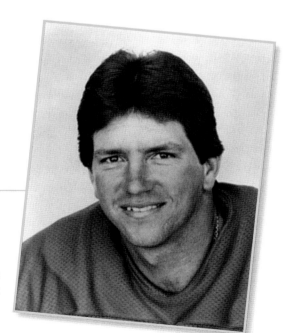

Tommy Kramer was the 27th overall pick in the 1977 NFL Draft.

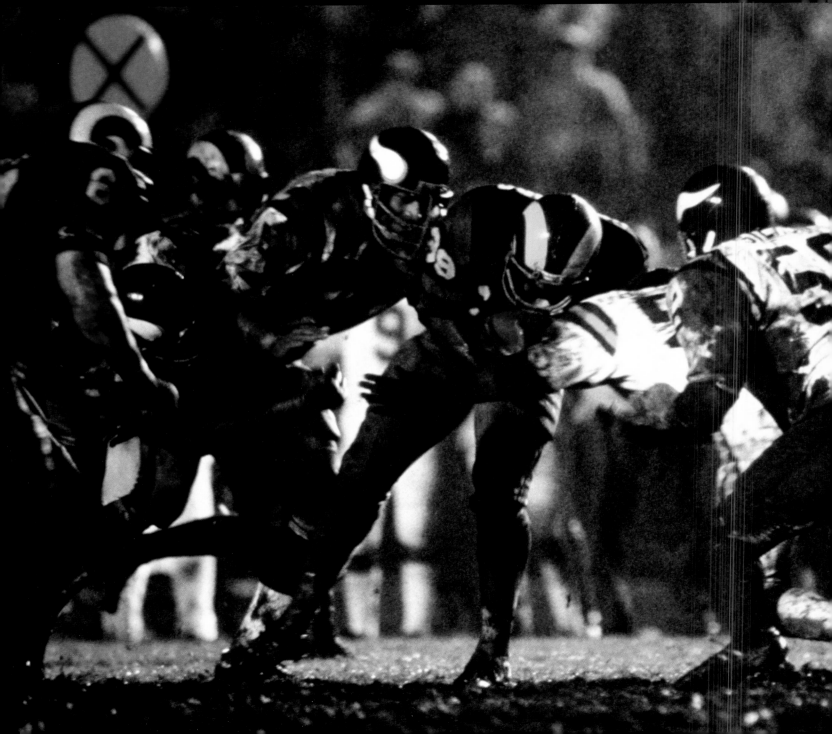

All-1970s Defense

DEFENSIVE ENDS: Carl Eller (1970–1978) and Jim Marshall (1970–1979). As it was in the 1960s, so it was in the 1970s. Carl Eller and Jim Marshall claim their spots on both squads. Eller made four Pro Bowls, three All-Pro teams, and the 1970s NFL All-Decade squad. He led the team in sacks four times. Marshall started every game the Minnesota Vikings ever played in the 1960s and 1970s.

DEFENSIVE TACKLES: Alan Page (1970–1978) and Doug Sutherland (1971–1979). Page became a dominant force in the 1970s, winning the MVP in 1971, earning seven trips to the Pro Bowl, five All-Pros, and landing a spot on the 1970s NFL All-Decade team. He led the team in tackles twice and sacks four times. After backing up Gary Larsen, Sutherland came into his own in 1975 and started 76 total games in the decade.

LINEBACKERS: Jeff Siemon (1972–1979), Wally Hilgenberg (1970–1979), and Matt Blair (1974–1979). Siemon manned the middle for most of the '70s, leading the team in tackles four times and making the same number of Pro Bowls. Hilgenberg made 95 starts and led the team in tackles once. Blair started 64 games. He made three Pro Bowls—and countless big plays via fumble recovery, interception, and blocked kick.

CORNERBACKS: Bobby Bryant (1970–1979) and Nate Wright (1971–1979). Bryant started 106 games and managed 38 interceptions, two Pro Bowl seasons, and numerous playoff heroics. He led the team three times in interceptions. Arriving via trade in 1971, Wright picked off 29 balls and compiled 85 starts. During the 1970s, Wright led the Vikings in picks twice and tied for the lead once.

SAFETIES: Paul Krause (1970–1979) and Jeff Wright (1971–1978). Krause may have snuck onto the 1960s all-decade team, but he emphatically earned his place on the 1970s squad. He enjoyed Pro Bowl seasons from 1971 to 1975 and added an All-Pro year in 1975, when he picked off 10 passes. For the decade, he stole 41 opponent passes and paced the Vikings in the category two times. Wright arrived in the 15th round of the 1971 draft. In his career, the former Golden Gopher grabbed 12 picks and nine fumble recoveries while making 62 starts.

PUNTER: Neil Clabo (1975–1977). Clabo's 39.9 yards per punt was Minnesota's best of the decade. He tied with Mike Eischeid for the decade's longest tenure as a punter.

PUNT RETURNER: Charlie West (1970–1973). West averaged just under six yards per return, which is slightly less than Bobby Bryant's average. It was a toss-up between the two, but West returned a few more punts: 64 to 57.

Ron Yary was first-team All-Pro from 1971 to 1976.

Miracle at the Met

In Week 15, with a tough road contest against the Oilers looming, the Vikings needed a victory at home against the playoff-bound Cleveland Browns to clinch a postseason berth.

The Vikings found themselves behind, 23–9, with about seven minutes to play in the fourth quarter. They cut that lead to 23–22, and they started the final drive on their own 20-yard line with 23 seconds left.

On first down, Tommy Kramer fired a ball to tight end Joe Senser, who pitched it to Ted Brown. The running back scampered to Cleveland's 46-yard line before stopping the clock by going out of bounds with five seconds remaining. On the last play of the game, Kramer heaved the ball toward the end zone in desperation. Browns and Vikings players leapt in the air and batted the ball. Ahmad Rashad stuck out his left hand, somehow pinned the ball against his hip, and backed a few steps across the goal line.

The miraculous catch sealed the win for the Vikings. It gave Minnesota the division title and a berth in the playoffs.

1981

7–9
Fourth Place

The 1981 football season was perhaps the streakiest in team history. The Vikings lost their first two games and then reeled off five straight victories. They followed that with two-game losing and two-game winning streaks, and they concluded by dropping the final five contests.

The Vikings lost four games by less than a touchdown. A campaign that seemed promising at 5–2 and then 7–4 ended ignobly with a 10–6 loss to the Kansas City Chiefs in the last-ever game at the beloved Metropolitan Stadium in Bloomington.

The Vikings offense, potent in the victories, proved inconsistent at best. The defense finished in the bottom quarter of the league.

Ted Brown became the second Vikings running back to surpass 1,000 yards in a season, joining Chuck Foreman by rushing for 1,063 yards. Tommy Kramer posted the most passing yards in a season by a Viking.

For the first time in team history, two Minnesota receivers surpassed the 1,000-yard mark: Joe Senser (1,004) and Sammy White (1,001).

After the season, the frozen ground of the Met gave way to the artificial turf of the Hubert H. Humphrey Metrodome. It was another reminder that a glorious chapter in Vikings history had ended.

Tight end Joe Senser joined linebacker Matt Blair and wide receiver Ahmad Rashad as Pro Bowl designees.

Pro Bowl Selections

- Matt Blair (LB)
- Ahmad Rashad (WR)
- Joe Senser (TE)

Schedule

OPPONENT	SCORE	RECORD
@ Tampa Bay Buccaneers	13–21	0–1
Oakland Raiders	10–36	0–2
W Detroit Lions	26–24	1–2
W @ Green Bay Packers	30–13	2–2
W Chicago Bears	24–21	3–2
W @ San Diego Chargers	33–31	4–2
W Philadelphia Eagles	35–23	5–2
@ St. Louis Cardinals	17–30	5–3
@ Denver Broncos	17–19	5–4
W Tampa Bay Buccaneers	25–10	6–4
W New Orleans Saints	20–10	7–4
@ Atlanta Falcons	30–31	7–5
Green Bay Packers	23–35	7–6
@ Chicago Bears	9–10	7–7
@ Detroit Lions	7–45	7–8
Kansas City Chiefs	6–10	7–9

Season Leaders

CATEGORY	TOTAL	PLAYER
Passing Yards	3,912	Tommy Kramer
Rushing Yards	1,063	Ted Brown
Receiving Yards	1,004	Joe Senser
Receptions	83	Ted Brown
Interceptions	4	Hannon/Teal
Sacks	6	Blair/Holloway/Martin
Points	97	Rick Danmeier

Key Additions:
Tim Irwin (draft)
Wade Wilson (draft)

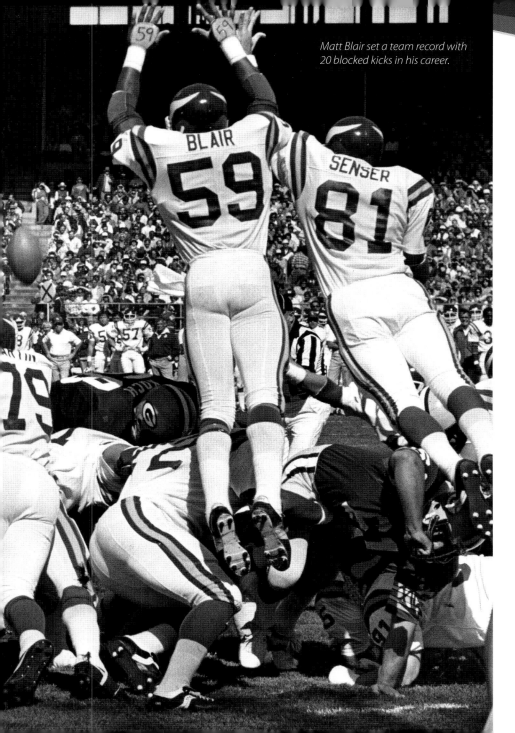

Matt Blair set a team record with 20 blocked kicks in his career.

Starting Lineup

OFFENSE	POSITION
Tommy Kramer	QB
Ted Brown	RB
Rickey Young	RB
Ahmad Rashad	WR
Sammy White	WR
Joe Senser	TE
Steve Riley	LT
Jim Hough	LG
Dennis Swilley	C
Wes Hamilton	RG
Ron Yary	RT

DEFENSE	POSITION
Doug Martin	DE
James White	DT
Mark Mullaney	DE
Fred McNeill	LB
Scott Studwell	LB
Jeff Siemon	LB
Matt Blair	LB
Willie Teal	CB
John Turner	CB
Tom Hannon	SS
Kurt Knoff	FS

SPECIAL TEAMS	POSITION
Rick Danmeier	K
Eddie Payton	KR
Greg Coleman	P
Eddie Payton	PR

5–4
Second Place (tie)

The NFL experienced its first in-season work stoppage in 1982. The players went on strike after the conclusion of Week 2. The strike lasted 57 days, and the NFL season decreased from 16 to 9 games. For the playoffs, 16 teams made the "Super Bowl Tournament." The Vikings were one of them.

Minnesota lost all three of its games against AFC East opponents but managed to post a 3–1 record against their NFC Central rivals.

A 31–27 Monday-night victory over the Cowboys in the regular-season finale clinched a playoff berth and proved to be a season highlight, despite Tony Dorsett's NFL-record 99-yard touchdown run. Dorsett's scamper was made even more impressive—or humiliating, depending upon one's allegiances—by the fact that the Cowboys had only 10 players on the field.

The Vikings won in the first round of the eight-team NFC playoffs, scoring a 30–24 comeback victory over Atlanta in the Metrodome's first-ever postseason game. The Falcons went ahead, 24–23, in the fourth quarter. But with 1:44 to play, Ted Brown scored from five yards out to give the Vikings a 30–24 lead. A John Turner interception sealed the victory.

The following week, John Riggins and eventual-Super-Bowl-champion Washington rolled over the Vikings, 21–7.

Key components to the team's offense during the 1980s were added in the draft, with running back Darrin Nelson coming in the first round and tight end Steve Jordan in the seventh.

Defensive end Doug Martin led the league in sacks and earned All-Pro honors, while Matt Blair attended his sixth straight Pro Bowl.

Pro Bowl Selections

- Matt Blair (LB)

Schedule

	OPPONENT	SCORE	RECORD
W	Tampa Bay Buccaneers	17–10	1–0
	@ Buffalo Bills	22–23	1–1
	@ Green Bay Packers	7–26	1–2
W	Chicago Bears	35–7	2–2
	@ Miami Dolphins	14–22	2–3
W	Baltimore Colts	13–10	3–3
W	@ Detroit Lions	34–31	4–3
	New York Jets	14–42	4–4
W	Dallas Cowboys	31–27	5–4
W	*Atlanta Falcons*	*30–24*	*1–0*
	@ Washington	*7–21*	*1–1*

Season Leaders

CATEGORY	TOTAL	PLAYER
Passing Yards	2,037	Tommy Kramer
Rushing Yards	515	Ted Brown
Receiving Yards	503	Sammy White
Receptions	31	Ted Brown
Interceptions	4	Willie Teal
Sacks	11.5	Doug Martin
Points	47	Rick Danmeier

Key Additions:
Steve Jordan (draft)
Darrin Nelson (draft)

Starting Lineup

OFFENSE	POSITION
Tommy Kramer	QB
Tony Galbreath	RB
Ted Brown	RB
Ahmad Rashad	WR
Sammy White	WR
Joe Senser	TE
Steve Riley	LT
Jim Hough	LG
Dennis Swilley	C
Wes Hamilton	RG
Tim Irwin	RT

DEFENSE	POSITION
Mark Mullaney	DE
Charlie Johnson	DT
Doug Martin	DE
Fred McNeill	LB
Scott Studwell	LB
Dennis Johnson	LB
Matt Blair	LB
Willie Teal	CB
John Swain	CB
Tom Hannon	SS
John Turner	FS

SPECIAL TEAMS	POSITION
Rick Danmeier	K
Jarvis Redwine	KR
Greg Coleman	P
Eddie Payton	PR

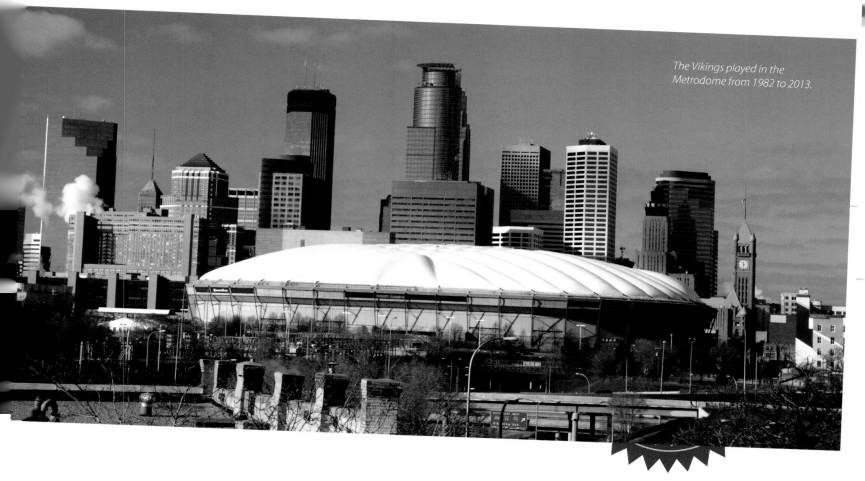

The Vikings played in the Metrodome from 1982 to 2013.

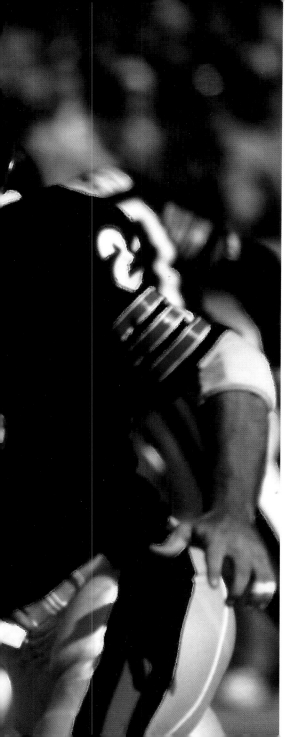

Scott Studwell

Scott Studwell arrived in Minnesota in 1977 as a ninth-round draft pick from the University of Illinois. He moved into the starting lineup in 1980. Studwell became famous among Vikings fans for playing with a blood-smeared uniform, and he became the backbone of some extremely talented Vikings defenses.

A two-time Pro Bowler, Studwell led the Vikings in tackles during eight seasons in the 1980s. When he retired after the 1990 season, he left as the Vikings' all-time leading tackler with 1,981.

In addition to Studwell, Joey Browner, Chris Doleman, Carl Lee, and Keith Millard were Pro Bowlers, ranking among the best at their positions when the Vikings made playoff appearances in 1987, 1988, and 1989.

Browner, Doleman, and Studwell have been inducted into the Vikings Ring of Honor.

1985

7–9
Third Place (tie)

Bud's back! Leading into the 1985 NFL season, that exclamation emanated from Minnesota Vikings fans across the Upper Midwest. Although the NFL has often been considered a player's league, Bud Grant proved that head coaches can make a significant difference.

In the season opener, an inspired Vikings roster notched a 28–21 win over the defending-NFL-champion San Francisco 49ers. Despite the presence of all-time greats Joe Montana and Jerry Rice, the best player on the field that day was Rufus Bess, who won Player of the Week honors behind 10 tackles, three forced fumbles, a fumble recovery, and an interception.

The Vikings won, 31–16, the following week against Tampa Bay, which set up a Thursday night showdown against the 2–0 Bears. The Vikings led, 17–9, in the third quarter. But Chicago's injured quarterback, Jim McMahon, came off the bench to torch the Vikings with three touchdown passes in the second half. Chicago prevailed, 33–24.

The rest of the season proved hit or miss as the Vikings dropped four games by a field goal or less. In a loss to the Lions, Scott Studwell set a franchise record with 24 tackles in a game.

Late in the season, Minnesota pulled off a wild 23-point fourth quarter comeback against the Eagles. Trailing 23-0 with 8:27 left in the game, Wade Wilson hit Allen Rice for a seven-yard touchdown pass. Willie Teal returned a Ron Jaworski fumble 65 yards for a touchdown, and Anthony Carter hauled in 36- and 42-yard touchdown receptions to cap off the scoring.

Grant stabilized the team, and the future looked bright. After the conclusion of the season, Grant retired again. Longtime offensive coordinator Jerry Burns assumed the head-coaching duties.

Pro Bowl Selections

• Joey Browner (S)

Schedule

OPPONENT	SCORE	RECORD
W San Francisco 49ers	28–21	1–0
W @ Tampa Bay Buccaneers	31–16	2–0
L Chicago Bears	24–33	2–1
W @ Buffalo Bills	27–20	3–1
L @ Los Angeles Rams	10–13	3–2
L @ Green Bay Packers	17–20	3–3
W San Diego Chargers	21–17	4–3
L @ Chicago Bears	9–27	4–4
W Detroit Lions	16–13	5–4
L Green Bay Packers	17–27	5–5
L @ Detroit Lions	21–41	5–6
L New Orleans Saints	23–30	5–7
W @ Philadelphia Eagles	28–23	6–7
W Tampa Bay Buccaneers	26–7	7–7
L @ Atlanta Falcons	13–14	7–8
L Philadelphia Eagles	35–37	7–9

Season Leaders

CATEGORY	TOTAL	PLAYER
Passing Yards	3,522	Tommy Kramer
Rushing Yards	893	Darrin Nelson
Receiving Yards	821	Anthony Carter
Receptions	68	Steve Jordan
Interceptions	5	John Turner
Sacks	11	Keith Millard
Points	86	Jan Stenerud

Key Additions:
Anthony Carter (trade)
Chris Doleman (draft)
Kirk Lowdermilk (draft)
Keith Millard (1984 draft)

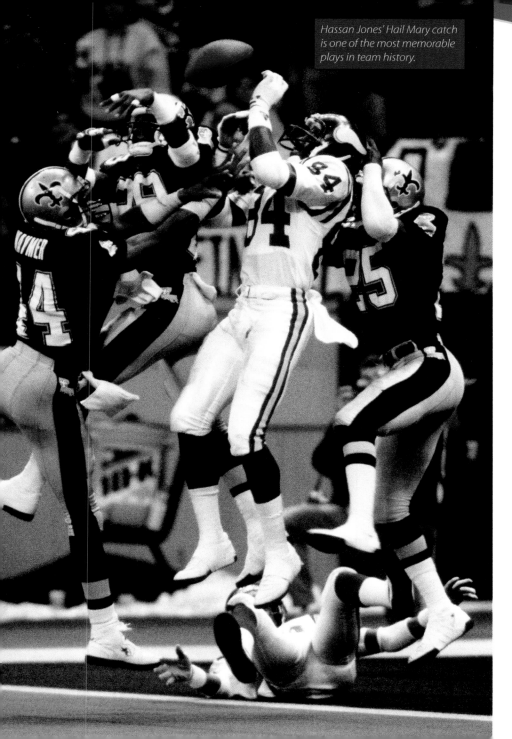

Hassan Jones' Hail Mary catch is one of the most memorable plays in team history.

Starting Lineup

OFFENSE	POSITION
Wade Wilson	QB
Darrin Nelson	RB
Alfred Anderson	RB
Anthony Carter	WR
Leo Lewis	WR
Steve Jordan	TE
Gary Zimmerman	LT
Dave Huffman	LG
Kirk Lowdermilk	C
Greg Koch	RG
Tim Irwin	RT

DEFENSE	POSITION
Chris Doleman	DE
Keith Millard	DT
Henry Thomas	DT
Doug Martin	DE
David Howard	LB
Scott Studwell	LB
Jesse Solomon	LB
Carl Lee	CB
Wymon Henderson	CB
Joey Browner	SS
John Harris	FS

SPECIAL TEAMS	POSITION
Chuck Nelson	K
Neal Guggemos	KR
Greg Coleman	P
Leo Lewis	PR

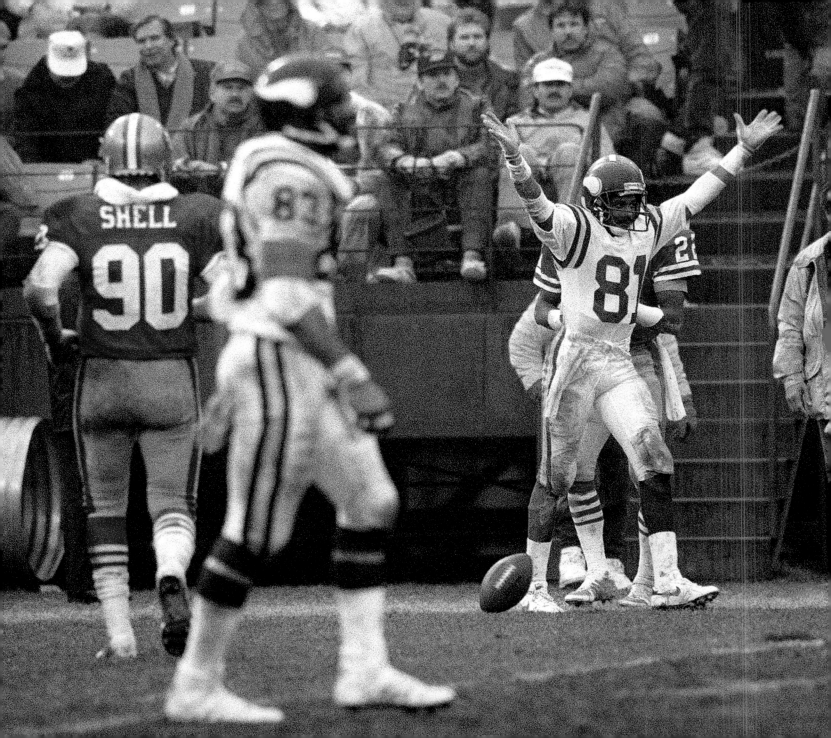

Anthony Carter Dominates

Named one of the 50 Greatest Vikings in 2010, Anthony Carter was acquired from the Miami Dolphins in one of the most lopsided trades in franchise history. In 1985, the Vikings sent linebacker Robin Sendlein and a second-round pick for the wide receiver.

During his Vikings career, Carter hauled in 478 passes for 7,636 yards and 52 touchdowns. No Vikings fan from the 1980s will ever forget his 1987 postseason dominance. He kickstarted the Vikings' 44–10 thrashing of the New Orleans Saints with an 84-yard punt return for a touchdown. He added six catches for 79 yards and a receiving touchdown too.

The following week, Carter upped the ante against the San Francisco 49ers, posting an NFL-playoff-record 227 yards receiving on 10 catches. He also added a 30-yard rush for good measure. Carter was the single most important piece in the Vikings' historical upset of the 49ers, who were an astounding 11-point favorite.

Carter made three Pro Bowls, posted three 1,000-yard receiving seasons, and, in 1987, led the NFL in yards per catch with an average of 24.3.

11-5
Second Place

Expectations were understandably high going into the 1988 season. Three out of the last four Super Bowl winners had been losers of the NFC Championship the year before. Many thought the Vikings would continue the trend.

The season began with a tough 13–10 road loss to a Bills team on the verge of becoming a Super Bowl contender. The following week, the Vikings hammered the Patriots, 36–6, then the Bears, 31–7. In a Week 4 win against the Eagles, the Vikings sacked quarterback Randall Cunningham eight times, with half of them coming from defensive tackle Keith Millard.

The Vikings were 5–3 when they visited San Francisco. Minnesota came up short—losing on a 49-yard touchdown scamper by quarterback Steve Young. (The dramatic run, which occurred in the final two minutes of the game, is widely considered one of the best plays in NFL history.)

After that heartbreaker, the Vikings rebounded with five straight wins. In four of them, they did not allow a touchdown. Against the Lions, the Purple's defense gave up just 60 total yards and a measly three first downs.

The Vikings swept the Bears but somehow dropped two games to a Green Bay Packers team that finished 4–12. The first defeat, 34–14, served as the Vikings' only loss in the Metrodome that year. The two losses ultimately cost Minnesota the division title.

In the postseason's Wild Card round, Minnesota met their longtime playoff nemesis the Los Angeles Rams. The California team did not fare better in the climate-controlled Metrodome than it had in the frigid, open-air Met. The Vikings handled the Rams, 28–17.

The following week, the Vikings lost, 34–9, to the 49ers (who were on their way to the first of back-to-back Super Bowl victories).

The team's All-Pros included Joey Browner, Carl Lee, Keith Millard, and Gary Zimmerman. That quartet made the Pro Bowl, as did Anthony Carter, Chris Doleman, Steve Jordan, Scott Studwell, and Wade Wilson.

Schedule

OPPONENT	SCORE	RECORD
@ Buffalo Bills	10–13	0–1
W New England Patriots	36–6	1–1
W @ Chicago Bears	31–7	2–1
W Philadelphia Eagles	23–21	3–1
L @ Miami Dolphins	7–24	3–2
W Tampa Bay Buccaneers	14–13	4–2
L Green Bay Packers	14–34	4–3
W @ Tampa Bay Buccaneers	49–20	5–3
L @ San Francisco 49ers	21–24	5–4
W Detroit Lions	44–17	6–4
W @ Dallas Cowboys	43–3	7–4
W Indianapolis Colts	12–3	8–4
W @ Detroit Lions	23–0	9–4
W New Orleans Saints	45–3	10–4
L @ Green Bay Packers	6–18	10–5
W Chicago Bears	28–27	11–5
W *Los Angeles Rams*	*28–17*	*1–0*
L *@ San Francisco 49ers*	*9–34*	*1–1*

Season Leaders

CATEGORY	TOTAL	PLAYER
Passing Yards	2,746	Wade Wilson
Rushing Yards	380	Darrin Nelson
Receiving Yards	1,225	Anthony Carter
Receptions	72	Anthony Carter
Interceptions	8	Carl Lee
Sacks	8	Doleman/Millard
Points	108	Chuck Nelson

Key Additions:
Randall McDaniel (draft)

Starting Lineup

Anthony Carter WR CB Carl Lee

Gary Zimmerman LT DE Chris Doleman

Darrin Nelson RB

Randall McDaniel LG DT Keith Millard

 LB David Howard

 LB Scott Studwell

SS Joey Browner

Wade Wilson QB Kirk Lowdermilk C

Terry Tausch RG DT Henry Thomas

 LB Jesse Solomon

FS John Harris

Alfred Anderson RB

Tim Irwin RT DE Doug Martin

Steve Jordan TE

K Chuck Nelson
KR Darryl Harris
P Bucky Scribner
PR Leo Lewis

Hassan Jones WR CB Issiac Holt

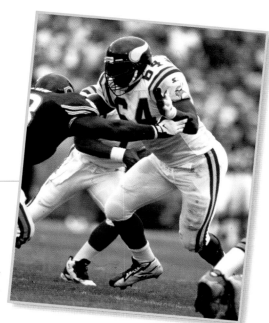

Pro Bowl Selections

- Joey Browner (S)
- Anthony Carter (WR)
- Chris Doleman (DE)
- Steve Jordan (TE)
- Carl Lee (CB)
- Keith Millard (DT)
- Scott Studwell (LB)
- Wade Wilson (QB)
- Gary Zimmerman (T)

Randall McDaniel is arguably the best guard in NFL history.

10–6
First Place

The Vikings closed out the decade the same way they opened the 1980s: clinching a division title (their only two of the 1980s).

The inconsistencies that plagued the Vikings in recent years were evident in the first two weeks of the season. The Vikings blew out a good Houston team, 38–7, and then lost to the Bears by an identical score.

The big story of the season was the acquisition of running back Herschel Walker from Dallas on October 12. The talent-laden Vikings seemed to need only a top-flight running back to put them over the hump. The first two times Walker touched the ball in purple, he returned a kickoff 40 yards and went for 47 yards on a running play—famously losing his shoe. Walker finished the day with 148 yards rushing in a 26–14 victory over the Packers.

In November, the Vikings defeated the Rams, 23–21, in overtime without scoring a touchdown. With under 10 seconds to play, Hassan Jones made a leaping Hail Mary catch (he had another in the regular-season finale against Cincinnati) of 43 yards to set up Rich Karlis's seventh field goal. It tied the score at 21–21. Improbably, the Vikings won the game in overtime when Mike Merriweather blocked a punt for a safety—the first overtime game in NFL history decided by a safety and the most points ever scored by a team without a touchdown.

The Vikings clinched the division on Christmas night against the Cincinnati Bengals, 29–21, but they were summarily drummed out of the playoffs by the 49ers, who dominated them, 41–13.

Chris Doleman led the league with 21 sacks. Keith Millard posted 18 sacks and won the NFL Defensive Player of the Year award. Both were All-Pro.

Schedule

OPPONENT	SCORE	RECORD
W Houston Oilers	38–7	1–0
L @ Chicago Bears	7–38	1–1
L @ Pittsburgh Steelers	14–27	1–2
W Tampa Bay Buccaneers	17–3	2–2
W Detroit Lions	24–17	3–2
W Green Bay Packers	26–14	4–2
W @ Detroit Lions	20–7	5–2
L @ New York Giants	14–24	5–3
W Los Angeles Rams (OT)	23–21	6–3
W @ Tampa Bay Buccaneers	24–10	7–3
L @ Philadelphia Eagles	9–10	7–4
L @ Green Bay Packers	19–20	7–5
W Chicago Bears	27–16	8–5
W Atlanta Falcons	43–17	9–5
L @ Cleveland Browns (OT)	17–23	9–6
W Cincinnati Bengals	29–21	10–6
L @ San Francisco 49ers	13–41	0–1

Season Leaders

CATEGORY	TOTAL	PLAYER
Passing Yards	2,543	Wade Wilson
Rushing Yards	669	Herschel Walker
Receiving Yards	1,066	Anthony Carter
Receptions	65	Anthony Carter
Interceptions	5	Joey Browner
Sacks	21	Chris Doleman
Points	120	Rich Karlis

Pro Bowl Selections

- Joey Browner (S)
- Anthony Carter (WR)
- Chris Doleman (DE)
- Steve Jordan (TE)
- Carl Lee (CB)
- Randall McDaniel (G)
- Keith Millard (DT)
- Gary Zimmerman (T)

Key Additions:
Mike Merriweather (trade)
Herschel Walker (trade)

Starting Lineup

OFFENSE	POSITION
Wade Wilson	QB
Herschel Walker	RB
Alfred Anderson	RB
Anthony Carter	WR
Hassan Jones	WR
Steve Jordan	TE
Gary Zimmerman	LT
Randall McDaniel	LG
Kirk Lowdermilk	C
Todd Kalis	RG
Tim Irwin	RT

DEFENSE	POSITION
Chris Doleman	DE
Keith Millard	DT
Henry Thomas	DT
Al Noga	DE
Mike Merriweather	LB
Scott Studwell	LB
Ray Berry	LB
Carl Lee	CB
Najee Mustafaa	CB
Joey Browner	SS
Travis Curtis	FS

SPECIAL TEAMS	POSITION
Rich Karlis	K
Herschel Walker	KR
Bucky Scribner	P
Leo Lewis	PR

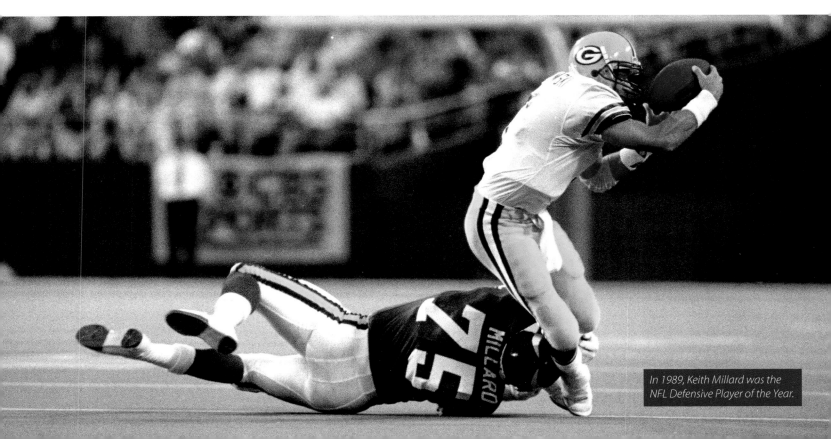

In 1989, Keith Millard was the NFL Defensive Player of the Year.

All-1980s Offense

QUARTERBACK: Tommy Kramer (1980–1989). Kramer started 93 games in the decade and tossed 131 total touchdowns, while racking up 20,903 yards. He was named to the Pro Bowl in 1986.

RUNNING BACKS: Ted Brown (1980–1986) and Darrin Nelson (1982–1989). A versatile tandem, Brown rushed for 3,995 yards and 39 touchdowns, while Nelson logged 4,016 yards on the ground. Brown led the team in rushing three times, Nelson five times. Both were excellent receivers as Nelson caught 232 balls for 2,060 yards, and Brown had 308 receptions for 2,653 yards. Brown led the team in receptions in 1981 and 1982. Nelson did so in 1983 when he also led the Vikings in receiving yards. Additionally, Nelson gained more than 2,500 yards in kickoff and punt returns.

WIDE RECEIVERS: Anthony Carter (1985–1989) and Sammy White (1980–1985). Coming to the Vikings in one of the best trades they ever made, Carter grabbed 256 passes for 4,720 yards during the 1980s. He was the best Vikings player during their 1987 postseason run, and he made three trips to the Pro Bowl. From 1987 to 1989, Carter led the Vikings in catches and yards receiving. White earned his Pro Bowls in the 1970s, but he continued his impressive play into the '80s. He grabbed 206 total receptions for 3,278 yards, giving him better numbers than Ahmad Rashad for the decade. White finished first on the 1982 squad in receiving yards.

TIGHT END: Steve Jordan (1982–1989). The Vikings' definitive tight end of the 1980s, Jordan started 92 games, made four Pro Bowls, and caught 309 passes—which was tops for any Vikings player in the decade. He turned those receptions into 4,074 yards and 20 touchdowns. Twice Jordan topped the team in receptions, and in 1986 he led Minnesota in receiving yards.

CENTER: Dennis Swilley (1980–1983, 1985–1987). Swilley retired for a year in 1984, but sandwiched between that season, he started 85 games at center, which more than doubles Kirk Lowdermilk's total.

GUARDS: Terry Tausch (1982–1988) and Jim Hough (1980–1986). Tausch, a second-round draft choice, made 68 starts for the Vikings in the 1980s. Hough, Tausch's counterpart on the left side earned 67 starts during the decade.

TACKLES: Tim Irwin (1981–1989) and Gary Zimmerman (1986–1989). Irwin emerged as a regular player in 1982 and started every non-replacement game (117 total) for the rest of the decade. On his way to the Pro Football Hall of Fame, Zimmerman was named to the Pro Bowl three times, was All-Pro twice, and started 60 games for the Vikings in the 1980s.

KICKER: Jan Stenerud (1984–1985). The Vikings shuffled through kickers in the 1980s. Although Rick Danmeier and Chuck Nelson each played a season longer, Stenerud made the Pro Bowl in 1984 and notched 176 points over his two campaigns.

KICK RETURNER: Eddie Payton (1980–1982). Payton had a 22.6-yards-per-return average, one touchdown, and the most kickoff-return yardage in the decade with 2,353.

—Data and statistics are for this decade only, unless otherwise noted.—

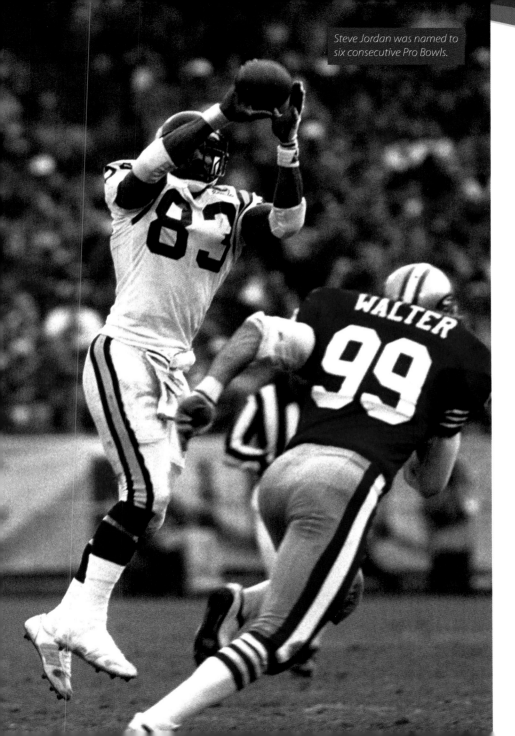

Steve Jordan was named to six consecutive Pro Bowls.

Starting Lineup

OFFENSE	POSITION
Rich Gannon	QB
Herschel Walker	RB
Terry Allen	RB
Anthony Carter	WR
Cris Carter	WR
Steve Jordan	TE
Gary Zimmerman	LT
Randall McDaniel	LG
Kirk Lowdermilk	C
Todd Kalis	RG
Tim Irwin	RT

DEFENSE	POSITION
Chris Doleman	DE
Ken Clarke	DT
Henry Thomas	DT
Al Noga/John Randle	DE
Mike Merriweather	LB
Ray Berry	LB
Jimmy Williams	LB
Najee Mustafaa	CB
Carl Lee	CB
Joey Browner	SS
Felix Wright	FS

SPECIAL TEAMS	POSITION
Fuad Reveiz	K
Darrin Nelson	KR
Harry Newsome	P
Leo Lewis	PR

11–5
First Place

Dennis Green became only the fifth Vikings head coach in 32 seasons—and he immediately injected life into the franchise.

After a preseason in which the Vikings outscored their opponents, 140–6, they slogged out a tough overtime road win against Green Bay, 23–20. It was the type of gut-check game that the team had seldom won in the previous few years.

A week later, they faced a setback against Detroit. The Lions scored touchdowns on a punt return, blocked field goal return, and fumble recovery. But after that debacle, the Vikings won their next four in a row. Included in that stretch was a 21–20 come-from-behind victory against Chicago. The Vikings scored all of their points in the fourth quarter. Todd Scott's interception return for a touchdown triggered the rally.

Inconsistent quarterback play dogged the team, though, as Rich Gannon made 12 starts and Sean Salisbury four. The Vikings clinched their division with a grueling, 6–3 victory in Pittsburgh, winning with tough defense and two fourth-quarter Fuad Reveiz field goals.

The following week, Minnesota prevented the Packers from making the postseason by whipping them, 27–7, in the season finale.

The lack of a consistent offense caught up to the Vikings in the playoffs. Washington dismissed them from the postseason, 24–7.

Despite or perhaps in part due to the team's quarterback woes, Terry Allen set a team record with 1,201 rushing yards.

Ed McDaniel (fifth round) and Brad Johnson (ninth round) joined the team via the draft.

Five Vikings were named All-Pro: Chris Doleman, Randall McDaniel, Audray McMillian, Todd Scott, and Gary Zimmerman. Henry Thomas and every All-Pro made the Pro Bowl.

Schedule

	OPPONENT	SCORE	RECORD
W	@ Green Bay Packers (OT)	23–20	1–0
L	@ Detroit Lions	17–31	1–1
W	Tampa Bay Buccaneers	26–20	2–1
W	@ Cincinnati Bengals	42–7	3–1
W	Chicago Bears	21–20	4–1
W	Detroit Lions	31–14	5–1
L	Washington	13–15	5–2
W	@ Chicago Bears	38–10	6–2
W	@ Tampa Bay Buccaneers	35–7	7–2
L	Houston Oilers	13–17	7–3
W	Cleveland Browns	17–13	8–3
W	@ Los Angeles Rams	31–17	9–3
L	@ Philadelphia Eagles	17–28	9–4
L	San Francisco 49ers	17–20	9–5
W	@ Pittsburgh Steelers	6–3	10–5
W	Green Bay Packers	27–7	11–5
L	*Washington*	*7–24*	*0–1*

Season Leaders

CATEGORY	TOTAL	PLAYER
Passing Yards	1,905	Rich Gannon
Rushing Yards	1,201	Terry Allen
Receiving Yards	681	Cris Carter
Receptions	53	Cris Carter
Interceptions	8	Audray McMillian
Sacks	14.5	Chris Doleman
Points	102	Fuad Reveiz

Key Additions:
Brad Johnson (draft)
Ed McDaniel (draft)

Starting Lineup

Henry Thomas made the Pro Bowl in 1991 and 1992.

Anthony Carter (WR) — (CB) Audray McMillian

Mike Tice (TE)

Everett Lindsay (LT) — (DE) Chris Doleman

Terry Allen (RB)

Randall McDaniel (LG) — (DT) John Randle

Rich Gannon (QB) — Kirk Lowdermilk (C)

Brian Habib (RG) — (DT) Henry Thomas

Tim Irwin (RT) — (DE) Al Noga

Steve Jordan (TE)

Cris Carter (WR) — (CB) Carl Lee

(LB) Mike Merriweather

(SS) Todd Scott

(LB) Jack Del Rio

(FS) Felix Wright

(LB) Carlos Jenkins

K Fuad Reveiz
KR Darrin Nelson
P Harry Newsome
PR Anthony Parker

Vikings Record

Highest Career Punt Return Average:
Marcus Sherels: 10.5 yards (2010–2018, 2019)

Pro Bowl Selections

- Chris Doleman (DE)
- Randall McDaniel (G)
- Audray McMillian (CB)
- Todd Scott (S)
- Henry Thomas (DT)
- Gary Zimmerman (T)

Terry Allen:
1,201 Yards
1992

9–7
Second Place (tie)

Coach Dennis Green began housecleaning immediately upon his arrival. The roster saw significant changes in his first two years—with the dismissal of several veterans, including Joey Browner, Keith Millard, Herschel Walker, and Wade Wilson.

Disappointed with the quarterback play from the previous season, Green brought in former Vikings' nemesis Jim McMahon. The wily veteran proved serviceable. He showed his wear and tear, missing four games. But he won eight of the 12 that he started. The offense continued to be inconsistent and broke the 20-point mark only five times—although the team enjoyed two wins over Green Bay, a bright spot even in a mediocre season.

The first victory over the Packers occurred in Week 4. Wide receiver Eric Guliford got behind the Packers secondary in the waning seconds, caught a 45-yard pass (his only reception ever for the team), and went out of bounds. The play set up Fuad Reveiz's fifth field goal of the day, a 22-yarder that handed Green Bay a 15–13 loss. The second matchup ended after the Packers could not score despite managing a first-and-goal from the two-yard line late in the fourth quarter. Linebacker Bobby Abrams and safety Vencie Glenn provided big plays to keep the Packers out of the end zone, and the Vikings emerged with a 21–17 victory.

Midway through the season, running back Scottie Graham improbably became a short-term star. He went from working in a pharmacy to starting in the NFL after the Vikings signed him to bolster the running game. He led Minnesota in rushing for the season, highlighted by a 166-yard effort against the Chiefs.

The Vikings made the playoffs and traveled to New York, but they came up short, 17–10, against the Giants. McMahon demonstrated supreme toughness as he was battered mercilessly by the Giants' pass rush. Yet he continually picked himself up off the hardened artificial turf.

Randall McDaniel and John Randle earned All-Pro honors. Both made the Pro Bowl, along with Cris Carter and Chris Doleman.

Schedule

OPPONENT	SCORE	RECORD
@ Los Angeles Raiders	7–24	0–1
W Chicago Bears	10–7	1–1
W Green Bay Packers	15–13	2–1
@ San Francisco 49ers	19–38	2–2
W Tampa Bay Buccaneers	15–0	3–2
W @ Chicago Bears	19–12	4–2
Detroit Lions	27–30	4–3
San Diego Chargers	17–30	4–4
W @ Denver Broncos	26–23	5–4
@ Tampa Bay Buccaneers	10–23	5–5
New Orleans Saints	14–17	5–6
W @ Detroit Lions	13–0	6–6
Dallas Cowboys	20–37	6–7
W @ Green Bay Packers	21–17	7–7
W Kansas City Chiefs	30–10	8–7
W @ Washington	14–9	9–7
@ *New York Giants*	*10–17*	*0–1*

Season Leaders

CATEGORY	TOTAL	PLAYER
Passing Yards	1,968	Jim McMahon
Rushing Yards	488	Scottie Graham
Receiving Yards	1,071	Cris Carter
Receptions	86	Cris Carter
Interceptions	5	Vencie Glenn
Sacks	12.5	Doleman/Randle
Points	105	Fuad Reveiz

Key Additions:
Jeff Christy (free agent)
Robert Smith (draft)

Starting Lineup

Anthony Carter WR — CB Audray McMillian

Mike Tice TE

Everett Lindsay LT — DE Chris Doleman

Scottie Graham RB

Randall McDaniel LG — DT John Randle — LB Fred Strickland — SS Todd Scott

Jim McMahon QB — Adam Schreiber C — LB Jack Del Rio

Scott Adams RG — DT Henry Thomas — FS Vencie Glenn

Tim Irwin RT — DE Roy Barker — LB Carlos Jenkins

Steve Jordan TE

K Fuad Reveiz
KR Qadry Ismail
P Harry Newsome
PR Eric Guliford

Cris Carter WR — CB Carl Lee

Cris Carter led the Vikings in receptions his first four years.

Vikings Record

Highest Career Kickoff Return Average:
Cordarrelle Patterson: 30.4 yards (2013–2016)

Pro Bowl Selections

- Cris Carter (WR)
- Chris Doleman (DE)
- Randall McDaniel (G)
- John Randle (DT)

Jim McMahon in Minnesota
1993

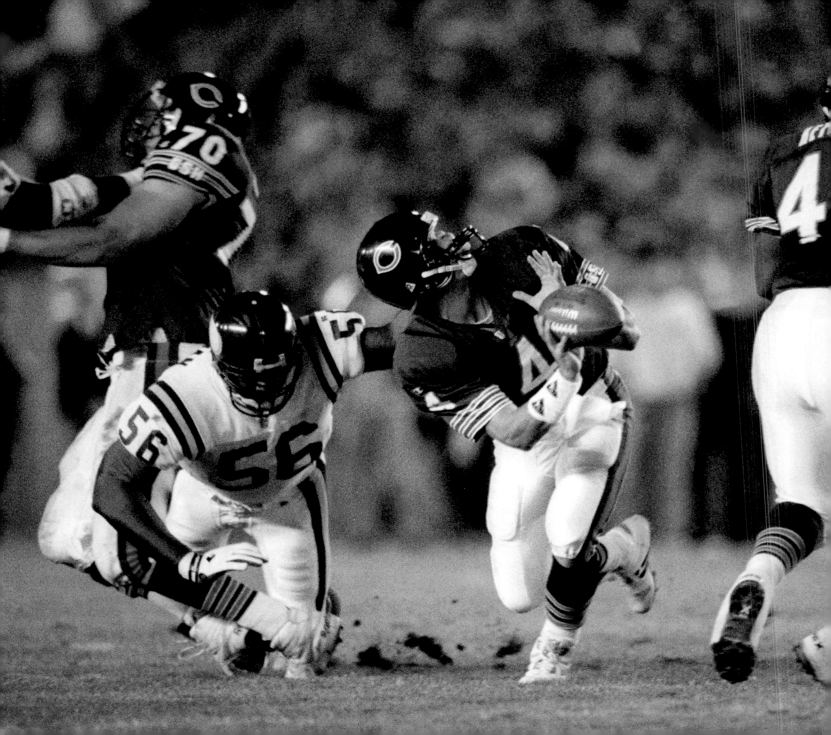

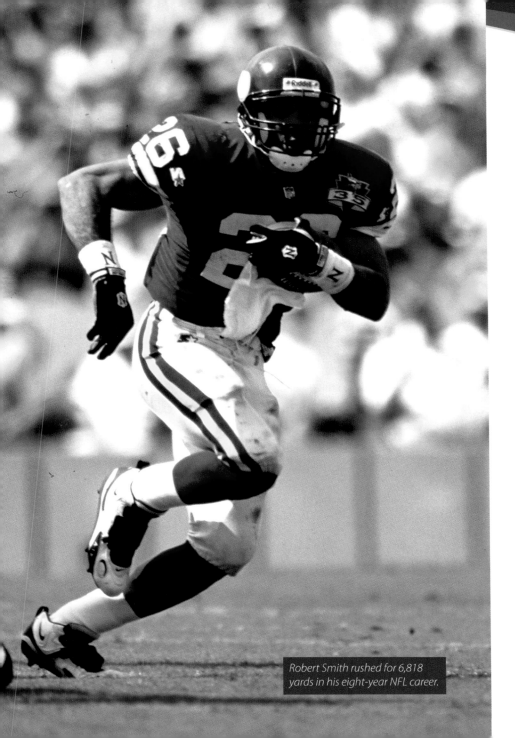

Robert Smith rushed for 6,818 yards in his eight-year NFL career.

Starting Lineup

OFFENSE	POSITION
Warren Moon	QB
Robert Smith	RB
Charles Evans	RB
Jake Reed	WR
Cris Carter	WR
Adrian Cooper	TE
Todd Steussie	LT
Randall McDaniel	LG
Jeff Christy	C
John Gerak	RG
Korey Stringer	RT

DEFENSE	POSITION
Derrick Alexander	DE
John Randle	DT
Esera Tuaolo	DT
Roy Barker	DE
Ed McDaniel	LB
Jack Del Rio	LB
Broderick Thomas	LB
Dewayne Washington	CB
Corey Fuller	CB
Harlon Barnett	SS
Vencie Glenn	FS

SPECIAL TEAMS	POSITION
Fuad Reveiz	K
Qadry Ismail	KR
Mike Saxon	P
David Palmer	PR

9–7
Second Place

The 1996 season became another transition year as injuries plagued starting quarterback Warren Moon, who was limited to eight games. Moon, initially injured in the opening contest, returned in Week 3. He was injured again in Week 8 and was lost for the season in the Week 10 defeat by Seattle.

Brad Johnson took over at quarterback and appeared in 12 of the team's contests, including the final six as a starter.

Aside from Moon's injuries, the season started well, with four straight victories, including a 30–21 win over eventual Super Bowl champions, Green Bay. That victory was sparked by the defense's seven quarterback sacks, including 3.5 sacks from John Randle.

The Vikings, particularly the offense, stalled midseason with four losses in a row. That dropped the Vikings to 5–5.

A home defeat versus Denver was a difficult pill to swallow, as Broncos receiver Ed McCaffrey caught the game-winning touchdown with 19 seconds left in the game. The fluke play featured two Vikings defenders batting the ball into the air, colliding with one another, and McCaffrey snatching the ball and falling forward into the end zone.

Following that heartbreak, the team finished strong, with three wins in the final four games. It was enough to clinch another postseason berth. The late-season hot streak was kicked off by a 16–13 overtime win against the Raiders, highlighted by a play in which Jake Reed took a slant pattern and turned it into an 82-yard touchdown.

In the playoffs, on the 21st anniversary of the Drew Pearson push-off, the Vikings met the Cowboys (defending Super Bowl champions) for the first time in the postseason since 1977. The 40–15 loss that followed dropped Dennis Green's playoff record to 0–4. Questions began to swirl about his future in Minnesota.

Randall McDaniel and John Randle achieved All-Pro status. The two were joined by Cris Carter as Pro Bowl selections.

Schedule

	OPPONENT	SCORE	RECORD
W	Detroit Lions	17–13	1–0
W	@ Atlanta Falcons	23–17	2–0
W	@ Chicago Bears	20–14	3–0
W	Green Bay Packers	30–21	4–0
L	@ New York Giants	10–15	4–1
W	Carolina Panthers	14–12	5–1
L	@ Tampa Bay Buccaneers	13–24	5–2
L	Chicago Bears	13–15	5–3
L	Kansas City Chiefs	6–21	5–4
L	@ Seattle Seahawks	23–42	5–5
W	@ Oakland Raiders (OT)	16–13	6–5
L	Denver Broncos	17–21	6–6
W	Arizona Cardinals	41–17	7–6
W	@ Detroit Lions	24–22	8–6
W	Tampa Bay Buccaneers	21–10	9–6
L	@ Green Bay Packers	10–38	9–7
L	*@ Dallas Cowboys*	*15–40*	*0–1*

Season Leaders

CATEGORY	TOTAL	PLAYER
Passing Yards	2,258	Brad Johnson
Rushing Yards	692	Robert Smith
Receiving Yards	1,320	Jake Reed
Receptions	96	Cris Carter
Interceptions	5	Orlando Thomas
Sacks	11.5	John Randle
Points	96	Scott Sisson

Key Additions:
N/A

Starting Lineup

Robert Smith (RB)

Warren Moon/
Brad Johnson (QB)

Charles Evans (RB)

Jake Reed (WR) — (CB) Dewayne Washington

Todd Steussie (LT) — (DE) Derrick Alexander

Randall McDaniel (LG) — (DT) John Randle

Jeff Christy (C)

John Gerak (RG) — (DT) Esera Tuaolo

Korey Stringer (RT) — (DE) Fernando Smith

Andrew Jordan (TE)

Cris Carter (WR) — (CB) Corey Fuller

(LB) Dixon Edwards

(LB) Jeff Brady

(LB) Darryl Talley

(SS) Robert Griffith

(FS) Orlando Thomas

K Scott Sisson
KR Qadry Ismail
P Mitch Berger
PR David Palmer

Robert Griffith made 84 starts and grabbed 17 interceptions between 1994 and 2001.

Vikings Record

Most Pro Bowl Seasons:
Randall McDaniel: 11 Pro Bowls (1989–2000)

Pro Bowl Selections

- Cris Carter (WR)
- Randall McDaniel (G)
- John Randle (DT)

4–0 to Start
the Season

1996

9–7
Fourth Place (tie)

The 1997 season got off to a promising start. After splitting the first four games, the Vikings reeled off six victories in a row to put themselves among the league's elite. During that stretch, quarterback Brad Johnson became the first player in NFL history to throw a touchdown pass to himself. At the three-yard line versus Carolina, Johnson attempted a pass that was deflected back to him. He caught it and scooted into the end zone for a three-yard touchdown pass and catch. The score also provided the margin of victory as Minnesota won, 21–14.

The team won three more games but then dropped five in a row.

Johnson went down with a neck injury during a December matchup with Green Bay on Monday Night Football. He watched as Randall Cunningham took over for the final three games.

At the end of the regular season, a 39–28 victory against the Colts clinched a playoff berth for the Vikings and made them one of four NFC Central teams in the postseason.

The Vikings traveled to the Meadowlands to face the New York Giants in a rain-soaked Wild Card contest. The Purple fell behind, 19–3, at the half, and it looked as if the Dennis Green era might come to an end with yet another one-and-done postseason. Trailing by nine with under two minutes to go, the Vikings staged their greatest playoff comeback. After forcing the Giants to punt, Cunningham hit Jake Reed for a 30-yard touchdown to cut the deficit to 22–20 with 90 seconds left. Special teams ace Chris Walsh recovered an onside kick, and the Vikings advanced the ball more than 50 yards in six plays to the Giants' five-yard line. There, Eddie Murray nailed a 24-yard field goal for a 23–22 victory.

The rain followed the Vikings to San Francisco, but good fortune did not. Their season ended with a muddy, sloppy, 38–22 defeat at the hands of the 49ers.

Randall McDaniel and John Randle were named All-Pro. Cris Carter and Todd Steussie joined them as picks for the Pro Bowl.

Schedule

OPPONENT	SCORE	RECORD
W @ Buffalo Bills	34–13	1–0
W @ Chicago Bears	27–24	2–0
Tampa Bay Buccaneers	14–28	2–1
@ Green Bay Packers	32–38	2–2
W Philadelphia Eagles	28–19	3–2
W @ Arizona Cardinals	20–19	4–2
W Carolina Panthers	21–14	5–2
W @ Tampa Bay Buccaneers	10–6	6–2
W New England Patriots	23–18	7–2
W Chicago Bears	29–22	8–2
@ Detroit Lions	15–38	8–3
@ New York Jets	21–23	8–4
Green Bay Packers	11–27	8–5
@ San Francisco 49ers	17–28	8–6
Detroit Lions	13–14	8–7
W Indianapolis Colts	39–28	9–7
W *@ New York Giants*	*23–22*	*1–0*
@ San Francisco 49ers	*22–38*	*1–1*

Season Leaders

CATEGORY	TOTAL	PLAYER
Passing Yards	3,036	Brad Johnson
Rushing Yards	1,266	Robert Smith
Receiving Yards	1,138	Jake Reed
Receptions	89	Cris Carter
Interceptions	4	Dewayne Washington
Sacks	15.5	John Randle
Points	84	Cris Carter

Key Additions:
Randall Cunningham (free agent)

Starting Lineup

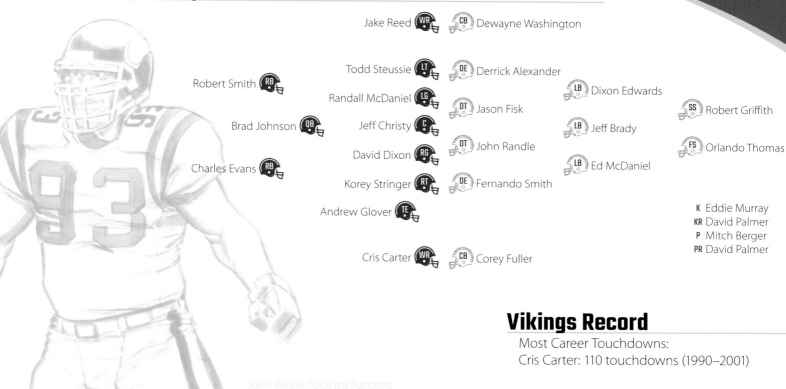

Jake Reed **WR** **CB** Dewayne Washington

Robert Smith **RB**

Todd Steussie **LT** **DE** Derrick Alexander

Randall McDaniel **LG** **DT** Jason Fisk **LB** Dixon Edwards

Brad Johnson **QB** Jeff Christy **C** **LB** Jeff Brady **SS** Robert Griffith

David Dixon **RG** **DT** John Randle **FS** Orlando Thomas

Charles Evans **RB** Korey Stringer **RT** **DE** Fernando Smith **LB** Ed McDaniel

Andrew Glover **TE**

K Eddie Murray
KR David Palmer
P Mitch Berger
PR David Palmer

Cris Carter **WR** **CB** Corey Fuller

John Randle holds the franchise record for most seasons leading the team in sacks (9).

Vikings Record

Most Career Touchdowns:
Cris Carter: 110 touchdowns (1990–2001)

Best Playoff Comeback
1997

Pro Bowl Selections

- Cris Carter (WR)
- Randall McDaniel (G)
- John Randle (DT)
- Todd Steussie (T)

15–1
First Place

The 1998 season remains bittersweet in the annals of Vikings lore. It is like a lemon covered with chocolate: sweet until you arrive at the core and then, oh, so bitter. The season was a wonderful, magical ride with a brutal crash at the end.

An argument can be made for this being the greatest team in Vikings history. Wide receiver Randy Moss fell to the Purple with the 21st pick of the draft, and the NFL felt his presence immediately. He caught 48- and 31-yard touchdowns in an opening-day 31–7 win over Tampa Bay. The following week against the Rams, Brad Johnson suffered a fracture in his ankle. Randall Cunningham led the team to victory—in that game and two more—before a Monday night showdown in Green Bay, where the Packers had not lost in 25 regular-season games. Cunningham threw for more than 400 yards, and Moss caught another pair of touchdowns as the Vikings cruised to a 37–24 victory.

The Vikings notched two more victories before traveling to Tampa, where they suffered their only regular-season defeat, 27–24.

Minnesota proceeded at a record-breaking clip, winning the rest of their games and putting up an NFL-record 556 points. The Purple broke the 30-point mark in 11 of their 16 regular-season games, and their lowest score was 24 points (twice). In addition, Gary Anderson became the first kicker to go without missing a field goal or an extra point in the regular season.

In the divisional playoff round, the Vikings dismissed the Cardinals by a score of 41–21. The following week, the Atlanta Falcons came to town for the NFC Championship. The Vikings held leads of 20–7 in the first half and 27–17 in the fourth quarter. However, Anderson infamously missed a 38-yard field goal (his first miss of the season) that would've all but clinched the game. The Vikings suffered an agonizing, 30–27 overtime loss.

Following the season, Dennis Green won the NFL's Coach of the Year, Cunningham was named Offensive Player of the Year, and Moss earned Rookie of the Year. Anderson, Cunningham, Moss, Robert Griffith, Randall McDaniel, and John Randle were named All-Pro.

Schedule

	OPPONENT	SCORE	RECORD
W	Tampa Bay Buccaneers	31–7	1–0
W	@ St. Louis Rams	38–31	2–0
W	Detroit Lions	29–6	3–0
W	@ Chicago Bears	31–28	4–0
W	@ Green Bay Packers	37–24	5–0
W	Washington	41–7	6–0
W	@ Detroit Lions	34–13	7–0
L	@ Tampa Bay Buccaneers	24–27	7–1
W	New Orleans Saints	31–24	8–1
W	Cincinnati Bengals	24–3	9–1
W	Green Bay Packers	28–14	10–1
W	@ Dallas Cowboys	46–36	11–1
W	Chicago Bears	48–22	12–1
W	@ Baltimore Ravens	38–28	13–1
W	Jacksonville Jaguars	50–10	14–1
W	@ Tennessee Oilers	26–16	15–1
W	*Arizona Cardinals*	*41–21*	*1–0*
L	*Atlanta Falcons (OT)*	*27–30*	*1–1*

Season Leaders

CATEGORY	TOTAL	PLAYER
Passing Yards	3,704	Randall Cunningham
Rushing Yards	1,187	Robert Smith
Receiving Yards	1,313	Randy Moss
Receptions	78	Cris Carter
Interceptions	7	Jimmy Hitchcock
Sacks	10.5	John Randle
Points	164	Gary Anderson

Key Additions:
Matt Birk (draft)
Randy Moss (draft)

Starting Lineup

Jake Reed Jimmy Hitchcock

Cris Carter

Todd Steussie John Randle

Robert Smith

Randall McDaniel Tony Williams Dwayne Rudd

 Robert Griffith

Randall Cunningham Jeff Christy Ed McDaniel

 Orlando Thomas

David Dixon Jerry Ball Dixon Edwards

Korey Stringer Derrick Alexander

Andrew Glover

K Gary Anderson
KR David Palmer
P Mitch Berger
PR David Palmer

Randy Moss Corey Fuller

Pro Bowl Selections

- Gary Anderson (K)
- Cris Carter (WR)
- Jeff Christy (C)
- Randall Cunningham (QB)
- Ed McDaniel (LB)
- Randall McDaniel (G)
- Randy Moss (WR)
- John Randle (DE)
- Robert Smith (RB)
- Todd Steussie (T)

Randall Cunningham was the NFL's top-rated quarterback in 1998.

The Freak

The 1998 Minnesota Vikings scored a franchise-record 64 touchdowns, and rookie wide receiver Randy Moss, one of the most football-savvy and physically gifted receivers ever to play the game, exploded onto the scene as a first-round draft pick. He posted 1,313 receiving yards and led the league with 17 touchdown receptions in his first campaign.

The high-powered Vikings offense staked the team to a 15–1 regular-season record in 1998 and an appearance in the NFC Championship.

With Moss and Cris Carter paired together from 1998 to 2001, the Vikings boasted one of the greatest receiving duos in NFL history.

For three consecutive seasons, starting in 1998, the Vikings enjoyed a top-five offense in terms of points and total yards.

Despite Carter's departure from the team after the 2001 season, "The Freak" (as Moss was affectionately known) continued his dominance, topping 1,300 yards receiving twice and once again leading the NFL with 17 touchdown receptions in 2003.

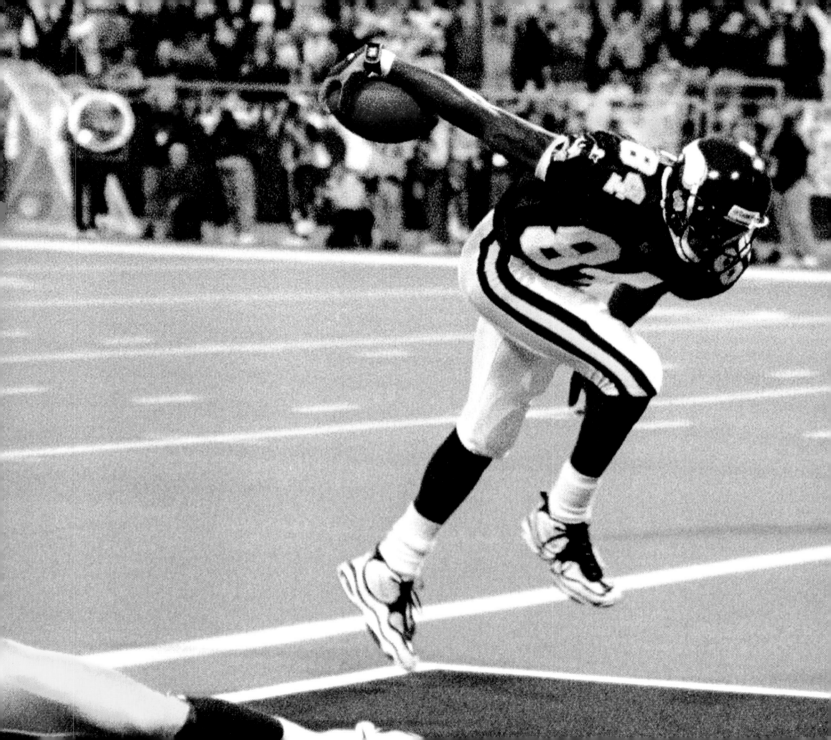

10–6
Second Place

Having come so close to the Super Bowl the previous season, 1999 held plenty of promise for the Vikings. The team avenged the NFC Championship Game by downing the Falcons in Atlanta, 17–14, on opening day.

Then things got rocky. Quarterback Randall Cunningham never came close to duplicating his monstrous 1998 performances. When Minnesota started 2–4, head coach Dennis Green turned to rifle-armed backup Jeff George.

The move sparked the team. The next week, with George at the helm, the Vikings put up 40 points. They won five straight games, and during the streak, George never posted a quarterback rating below 98.0.

After a pair of close losses, Minnesota ripped off a three-game winning streak to secure a postseason appearance.

Their playoff opponents created a turn-back-the-clock-to-the-1970s vibe. In the first-round, the Vikings hosted the Cowboys. George threw three touchdown passes, and Minnesota coasted to a 27–10 victory.

Next, the team traveled to Saint Louis. "The Greatest Show on Turf" (as the high-powered Rams offense was dubbed) charged to a 49–17 lead. Despite a Vikings' rally—and despite George passing for a Vikings' playoff record 423 yards—the eventual NFL champions held on for a 49–37 victory.

Mitch Berger, Cris Carter, and Jeff Christy earned All-Pro honors. All of them were named to the Pro Bowl, along with Randall McDaniel and Randy Moss.

Pro Bowl Selections

- Mitch Berger (P)
- Cris Carter (WR)
- Jeff Christy (C)
- Randall McDaniel (G)
- Randy Moss (WR)

Schedule

OPPONENT	SCORE	RECORD
W @ Atlanta Falcons	17–14	1–0
Oakland Raiders	17–22	1–1
@ Green Bay Packers	20–23	1–2
W Tampa Bay Buccaneers	21–14	2–2
Chicago Bears	22–24	2–3
@ Detroit Lions	23–25	2–4
W San Francisco 49ers	40–16	3–4
W @ Denver Broncos	23–20	4–4
W Dallas Cowboys	27–17	5–4
W @ Chicago Bears (OT)	27–24	6–4
W San Diego Chargers	35–27	7–4
@ Tampa Bay Buccaneers	17–24	7–5
@ Kansas City Chiefs	28–31	7–6
W Green Bay Packers	24–20	8–6
W @ New York Giants	34–17	9–6
W Detroit Lions	24–17	10–6
W *Dallas Cowboys*	*27–10*	*1–0*
@ St. Louis Rams	*37–49*	*1–1*

Season Leaders

CATEGORY	TOTAL	PLAYER
Passing Yards	2,816	Jeff George
Rushing Yards	1,015	Robert Smith
Receiving Yards	1,413	Randy Moss
Receptions	90	Cris Carter
Interceptions	3	Robert Griffith
Sacks	10	John Randle
Points	103	Gary Anderson

Key Additions:
Daunte Culpepper (draft)
Jim Kleinsasser (draft)

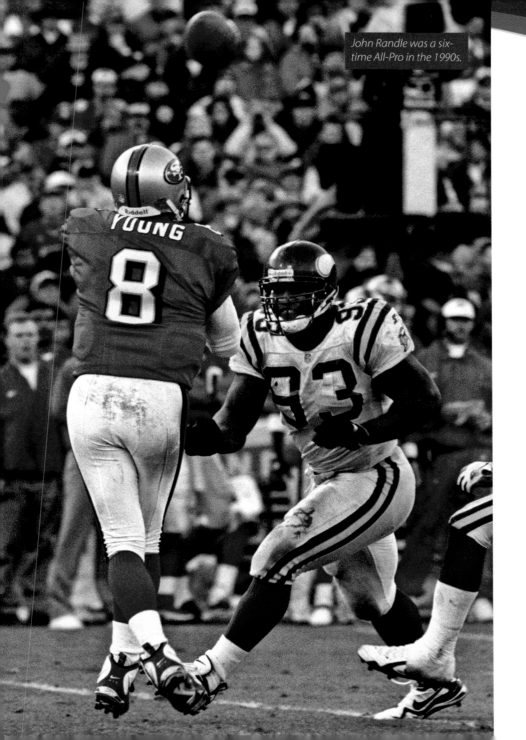

John Randle was a six-time All-Pro in the 1990s.

Starting Lineup

OFFENSE	POSITION
Jeff George	QB
Robert Smith	RB
Randy Moss	WR
Cris Carter	WR
Jake Reed	WR
Andrew Glover	TE
Todd Steussie	LT
Randall McDaniel	LG
Jeff Christy	C
David Dixon	RG
Korey Stringer	RT

DEFENSE	POSITION
John Randle	DE
Jerry Ball	DT
Tony Williams	DT
Duane Clemons	DE
Dwayne Rudd	LB
Ed McDaniel	LB
Kailee Wong	LB
Jimmy Hitchcock	CB
Kenny Wright	CB
Robert Griffith	SS
Orlando Thomas	FS

SPECIAL TEAMS	POSITION
Gary Anderson	K
Robert Tate	KR
Mitch Berger	P
Randy Moss	PR

All-1990s Offense

QUARTERBACK: Warren Moon (1994–1996). One of the best pure passers the franchise has ever had, Moon enjoyed two Pro Bowl seasons and owns the statistical advantage over challengers like Randall Cunningham and Brad Johnson. Moon tossed for 58 touchdowns and 10,102 yards before injuries derailed his stint with Minnesota.

RUNNING BACKS: Robert Smith (1993–1999) and Terry Allen (1991–1994). Blessed with breakaway speed while being a surprisingly tough inside runner, Smith tallied 5,297 rushing yards and 25 rushing touchdowns in the 1990s. He led the Vikings in rushing five times and made one Pro Bowl. Terry Allen rushed for 2,795 yards, leading the team twice, and he found the end zone 23 times.

WIDE RECEIVERS: Cris Carter (1990–1999) and Jake Reed (1991–1999). With the best pair of hands in Vikings' (if not in NFL) history, Carter enjoyed a phenomenal decade. He amassed 10,238 receiving yards on 835 catches, and he scored 95 touchdowns. He made seven Pro Bowl teams and two All-Pro squads. He led the Vikings in receptions nine of the decade's ten years and in receiving yards five times. Although it would be difficult to approach Carter's stratosphere, Reed put up more than respectable numbers. He snagged 386 balls for 6,124 yards and scored 32 touchdowns as the number-two receiver for a good part of the decade. Reed also led the Vikings in receiving yards in 1996 and 1997.

TIGHT END: Steve Jordan (1990–1994). While Andrew Glover had some nice seasons at the end of the decade, Jordan made the Pro Bowl twice, caught 189 passes for 2,233 yards, and easily claims this position for the second straight decade.

CENTER: Jeff Christy (1993–1999). The physical, tough, and mentally sharp Christy started 92 games and earned Pro Bowl honors twice.

GUARDS: Randall McDaniel (1990–1999) and David Dixon (1994–1999). It would be hard to top Randall McDaniel's decade. He made the Pro Bowl every season, was named All-Pro nine times, started every game, and made the NFL's All-Decade team. Dixon, a steady performer, made 57 starts opposite McDaniel during the 1990s.

TACKLES: Todd Steussie (1994–1999) and Korey Stringer (1995–1999). Steussie stepped into the lineup right away as a rookie and only missed one start during the remainder of the decade. He earned two trips to the Pro Bowl. Stringer, a rookie starter as well, made 75 starts. He and Steussie provided excellent bookend tackle play.

KICKER: Fuad Reveiz (1990–1995). Reveiz was a clutch kicker who made the Pro Bowl in 1994 and scored 598 points for Minnesota in the decade.

KICK RETURNER: David Palmer (1994–1999). Palmer edges out Qadry Ismail with a 22.7-yard average to Ismail's 22.3. Palmer also had one touchdown return.

PUNT RETURNER: David Palmer (1994–1999). Palmer averaged a very respectable 10.4 yards per return, took two punts all the way to the end zone, and led the league with a 13.2-yard average in 1995.

—Data and statistics are for this decade only, unless otherwise noted.—

Starting Lineup

OFFENSE	POSITION
Daunte Culpepper	QB
Michael Bennett	RB
Jim Kleinsasser	RB
Randy Moss	WR
D'Wayne Bates	WR
Byron Chamberlain	TE
Bryant McKinnie	LT
Corbin Lacina	LG
Matt Birk	C
David Dixon	RG
Chris Liwienski	RT

DEFENSE	POSITION
Lance Johnstone	DE
Chris Hovan	DT
Fred Robbins	DT
Kenny Mixon	DE
Nick Rogers	LB
Greg Biekert	LB
Henri Crockett	LB
Eric Kelly	CB
Brian Williams	CB
Corey Chavous	SS
Ronnie Bradford	FS

SPECIAL TEAMS	POSITION
Gary Anderson	K
Moe Williams	KR
Kyle Richardson	P
Nick Davis	PR

Players like Matt Birk, Daunte Culpepper, and Chris Walsh provided leadership for the Vikings.

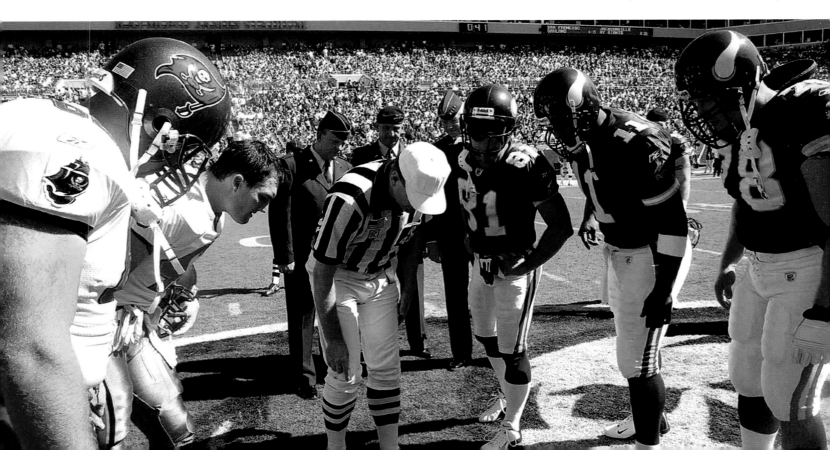

9–7
Second Place

On the list of odd seasons in the Vikings pantheon, 2003 ranks near the top. In April's draft, before play even began, the Vikings turned in their first-round draft pick late (for the second year in a row), causing them to be leap-frogged by both Jacksonville and Carolina. So instead of drafting seventh, Minnesota ended up picking ninth. It worked out in the team's favor, though. They wound up with All-Pro defensive tackle Kevin Williams.

When the season started, the Vikings began 6–0. In a 28–20 win over the Broncos, Randy Moss made one of his greatest plays. Right before the half, Moss caught a 44-yard pass from Daunte Culpepper. As Broncos defenders converged on him, Moss flipped a no-look lateral to Moe Williams, who took the ball the remaining 15 yards to the end zone as time expired.

The following week, the Vikings began a four-game losing streak. Three of the teams to which they fell (the Giants, Chargers, and Raiders) ultimately finished the season with 4–12 records.

The Vikings alternated between winning and losing the rest of the way. They stood at 9–6, going to Arizona for the regular season's final week. With one game left on the schedule, the Vikings simply needed to defeat the 3–12 Cardinals to clinch the division title. Instead, they managed the most painful regular-season loss in team history. The Cardinals won on a miraculous, last-second, 28-yard touchdown pass, which handed the division title to the Packers—and knocked the Vikings out of the playoffs.

Moss and Matt Birk earned All-Pro honors. Culpepper and Corey Chavous joined them as Pro Bowl members.

Pro Bowl Selections

- Matt Birk (C)
- Corey Chavous (S)
- Daunte Culpepper (QB)
- Randy Moss (WR)

Schedule

	OPPONENT	SCORE	RECORD
W	@ Green Bay Packers	30–25	1–0
W	Chicago Bears	24–13	2–0
W	@ Detroit Lions	23–13	3–0
W	San Francisco 49ers	35–7	4–0
W	@ Atlanta Falcons	39–26	5–0
W	Denver Broncos	28–20	6–0
L	New York Giants	17–29	6–1
L	Green Bay Packers	27–30	6–2
L	@ San Diego Chargers	28–42	6–3
L	@ Oakland Raiders	18–28	6–4
W	Detroit Lions	24–14	7–4
L	@ St. Louis Rams	17–48	7–5
W	Seattle Seahawks	34–7	8–5
L	@ Chicago Bears	10–13	8–6
W	Kansas City Chiefs	45–20	9–6
L	@ Arizona Cardinals	17–18	9–7

Season Leaders

CATEGORY	TOTAL	PLAYER
Passing Yards	3,479	Daunte Culpepper
Rushing Yards	745	Moe Williams
Receiving Yards	1,632	Randy Moss
Receptions	111	Randy Moss
Interceptions	9	Brian Russell
Sacks	10.5	Kevin Williams
Points	102	Elling/Moss

Key Additions:
E.J. Henderson (draft)
Kevin Williams (draft)

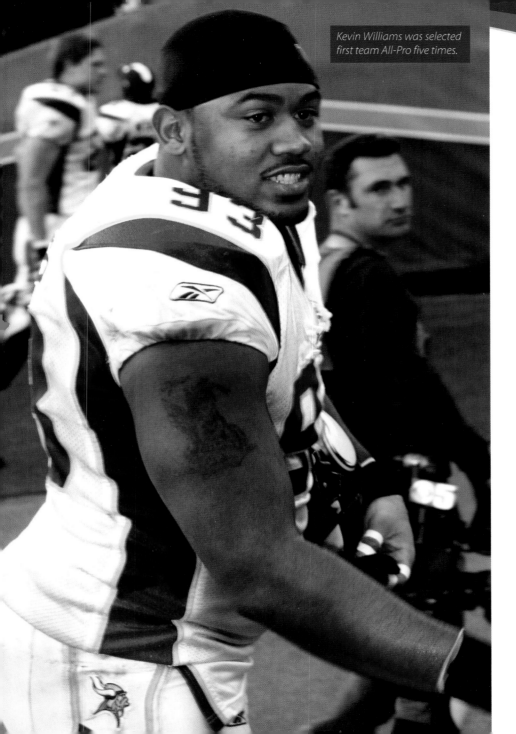

Kevin Williams was selected first team All-Pro five times.

Starting Lineup

OFFENSE	POSITION
Brad Johnson	QB
Mewelde Moore	RB
Travis Taylor	WR
Marcus Robinson	WR
Jermaine Wiggins	HB
Jim Kleinsasser	TE
Bryant McKinnie	LT
Chris Liwienski	LG
Melvin Fowler	C
Adam Goldberg	RG
Mike Rosenthal	RT

DEFENSE	POSITION
Erasmus James	DE
Pat Williams	DT
Kevin Williams	DT
Darrion Scott	DE
E.J. Henderson	LB
Sam Cowart	LB
Keith Newman	LB
Brian Williams	CB
Antoine Winfield	CB
Corey Chavous	SS
Darren Sharper	FS

SPECIAL TEAMS	POSITION
Paul Edinger	K
Koren Robinson	KR
Chris Kluwe	P
Mewelde Moore	PR

6–10
Third Place

The 2006 season marked the beginning of another chapter in Vikings' history. Mike Tice was out as head coach, and Daunte Culpepper was gone at quarterback. Tice was replaced by Brad Childress. Drafted in the second-round, Tarvaris Jackson was slated to become Culpepper's heir apparent.

The rookie watched and learned behind Brad Johnson (and started two late-season games). The Vikings envisioned Jackson hooking up on long passes with the prior year's first-rounder, the speedy wide receiver Troy Williamson. With Childress's reputation as an offensive guru, hopes were high that the Vikings would field a potent scoring attack.

The Vikings emerged victorious in Childress's first two games, and they worked their record to 4–2. One of the season's highlights came on Chester Taylor's franchise-record 95-yard touchdown run in a 31–13 victory on the road against Seattle.

After that offensive outburst, Minnesota's surprisingly sluggish offense caught up with them, and they suffered a four-game losing streak. In losses to the Patriots and 49ers, the Vikings' total scoring amounted to only a touchdown and a field goal. The team fared a little better in losses to the Packers and Dolphins, and they finally broke through with a 31–26 victory over the Cardinals. However, the team closed out the season with three losses to finish a disappointing 6–10.

Led by their stout defensive line, the Vikings gave up the league's fewest yards per rush. They achieved that success despite the absence of first-round draft pick Chad Greenway, who was lost for the season after suffering a knee injury in the team's first preseason game.

On-the-field success may have been limited in 2006, but the seeds were planted for a Purple resurgence. Steve Hutchinson made All-Pro in his first season with the Vikings, and defensive tackle Kevin Williams achieved the same status.

Pro Bowl participants included Hutchinson and Williams, along with their linemates Matt Birk and Pat Williams.

Schedule

	OPPONENT	SCORE	RECORD
W	@ Washington	19–16	1–0
W	Carolina Panthers (OT)	16–13	2–0
L	Chicago Bears	16–19	2–1
L	@ Buffalo Bills	12–17	2–2
W	Detroit Lions	26–17	3–2
W	@ Seattle Seahawks	31–13	4–2
L	New England Patriots	7–31	4–3
L	@ San Francisco 49ers	3–9	4–4
L	Green Bay Packers	17–23	4–5
L	@ Miami Dolphins	20–24	4–6
W	Arizona Cardinals	31–26	5–6
L	@ Chicago Bears	13–23	5–7
W	@ Detroit Lions	30–20	6–7
L	New York Jets	13–26	6–8
L	@ Green Bay Packers	7–9	6–9
L	St. Louis Rams	21–41	6–10

Season Leaders

CATEGORY	TOTAL	PLAYER
Passing Yards	2,750	Brad Johnson
Rushing Yards	1,216	Chester Taylor
Receiving Yards	651	Travis Taylor
Receptions	57	Travis Taylor
Interceptions	4	Sharper/Winfield/Smith
Sacks	5.5	Darrion Scott
Points	90	Ryan Longwell

Key Additions:
Chad Greenway (draft)
Steve Hutchinson (free agent)

Starting Lineup

Travis Taylor WR CB Fred Smoot

Bryant McKinnie LT DE Kenechi Udeze

Chester Taylor RB

Steve Hutchinson LG DT Pat Williams LB E.J. Henderson

Brad Johnson QB Matt Birk C LB Napoleon Harris SS Darren Sharper

Artis Hicks RG DT Kevin Williams FS Dwight Smith

Tony Richardson RB LB Ben Leber

Marcus Johnson RT DE Darrion Scott

Jim Kleinsasser TE

K Ryan Longwell
KR Bethel Johnson
P Chris Kluwe
PR Mewelde Moore

Troy Williamson WR CB Antoine Winfield

Pro Bowl Selections

- Matt Birk (C)
- Steve Hutchinson (G)
- Kevin Williams (DT)
- Pat Williams (DT)

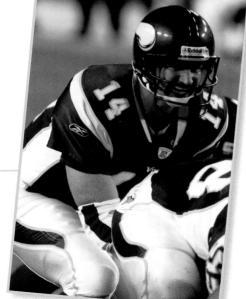

Brad Johnson was with Minnesota in 1992–1998 and 2005–2006.

8–8
Second Place

In 2007, the Vikings improved slightly on their record from the previous year, but the big story proved to be first-round draft pick and NFL Rookie of the Year, Adrian Peterson. The running back rushed for over 1,300 yards and notched the two best rushing days in team history.

Prior to Peterson's arrival, Chuck Foreman owned the Vikings' only 200-yard rushing performance in a game (exactly 200 yards). Peterson eclipsed Foreman's record with a 224-yard outburst in a 34–31 win against Chicago.

Three weeks later, versus San Diego, Peterson surpassed every other running back in NFL history with a record-setting 296-yard performance. (See page 130.) The game, a 35–17 Vikings win, also saw Chargers defensive back Antonio Cromartie return a missed field goal 109 yards for the longest play in NFL history (tied in 2013 on a kick return against the Packers by the Vikings' Cordarrelle Patterson).

Despite Peterson's highlights, the offense continued to perform unevenly. The team's record stood at 3–6 before Minnesota strung together a five-game winning streak. It began with a victory against the Raiders. Chester Taylor, starting for the injured Peterson, gashed Oakland for 164 yards rushing and three touchdowns. The following week, the defense carried the Purple to victory as they returned three interceptions for touchdowns against the eventual-Super-Bowl-champion New York Giants. Peterson returned for a matchup versus the Lions. He rushed for 116 yards and scored two touchdowns as Minnesota crushed Detroit, 42–10. In the fourth victory of the Vikings' streak, the 49ers held Peterson to only three yards, but Taylor compensated with an 84-yard touchdown run. The team moved to 8–6 after a 20–13 victory over the Bears.

In the final two weeks of the regular season, Minnesota had a chance to clinch a playoff berth, but they lost both games: first to Washington, 32–21, and then to Denver, 22–19, in overtime.

Peterson joined Steve Hutchinson and Kevin Williams as All-Pro selections. They also earned Pro Bowl trips, along with Matt Birk, Tony Richardson, Darren Sharper, and Pat Williams.

Schedule

OPPONENT	SCORE	RECORD
W Atlanta Falcons	24–3	1–0
@ Detroit Lions (OT)	17–20	1–1
@ Kansas City Chiefs	10–13	1–2
Green Bay Packers	16–23	1–3
W @ Chicago Bears	34–31	2–3
@ Dallas Cowboys	14–24	2–4
Philadelphia Eagles	16–23	2–5
W San Diego Chargers	35–17	3–5
@ Green Bay Packers	0–34	3–6
W Oakland Raiders	29–22	4–6
W @ New York Giants	41–17	5–6
W Detroit Lions	42–10	6–6
W @ San Francisco 49ers	27–7	7–6
W Chicago Bears	20–13	8–6
Washington	21–32	8–7
@ Denver Broncos (OT)	19–22	8–8

Season Leaders

CATEGORY	TOTAL	PLAYER
Passing Yards	1,911	Tarvaris Jackson
Rushing Yards	1,341	Adrian Peterson
Receiving Yards	647	Bobby Wade
Receptions	54	Bobby Wade
Interceptions	4	Sharper/Smith
Sacks	5	Edwards/Leber/Udeze
Points	99	Ryan Longwell

Key Additions:
Adrian Peterson (draft)
Brian Robison (draft)

Starting Lineup

Bobby Wade (WR) (CB) Cedric Griffin

Bryant McKinnie (LT) (DE) Ray Edwards

Adrian Peterson (RB)

Steve Hutchinson (LG) (LB) Chad Greenway

(DT) Pat Williams

Tarvaris Jackson (QB) Matt Birk (C) (LB) E.J. Henderson (SS) Darren Sharper

Anthony Herrera (RG) (DT) Kevin Williams (FS) Dwight Smith

Tony Richardson (RB) (LB) Ben Leber

Ryan Cook (RT) (DE) Kenechi Udeze

Visanthe Shiancoe (TE)

K Ryan Longwell
KR Aundrae Allison
P Chris Kluwe
PR Bobby Wade

Robert Ferguson (WR) (CB) Antoine Winfield

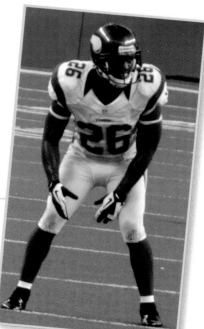

Antoine Winfield was with the Vikings for nine seasons.

Pro Bowl Selections

- Matt Birk (C)
- Steve Hutchinson (G)
- Adrian Peterson (RB)
- Darren Sharper (S)
- Kevin Williams (DT)
- Pat Williams (DT)

Peterson's Record-Breaking Day

The Vikings have twice been involved in the NFL's single-game rushing record. In 1977 they came out on the wrong end, yielding 275 yards to Chicago Bears great Walter Payton in a 10–7 loss.

Thirty years after Payton's performance, rookie Adrian Peterson posted a 296-yard day, breaking the record of 295 yards set by Jamal Lewis of the Baltimore Ravens in 2003. What makes Peterson's record even more amazing is that he only had 43 yards on 13 carries at halftime. His 253-yard performance in the second half would tie him for the 10th best rushing game ever.

Peterson scored on runs of 64 and 46 yards during his explosive second half, helping the Vikings coast to a 35–17 win against the Chargers.

Minnesota got the ball at their own 10-yard line late in the game, and Peterson needed 37 yards to break the record. On his first carry, he burst outside for 35 yards before Chargers defender Marlon McCree corralled him from behind, preventing what could have been a 90-yard touchdown run.

Peterson took one play off, then returned and finished the game with a three-yard run to set a new NFL record.

He finished with 30 carries for 296 yards and three touchdowns. He also had a 19-yard reception.

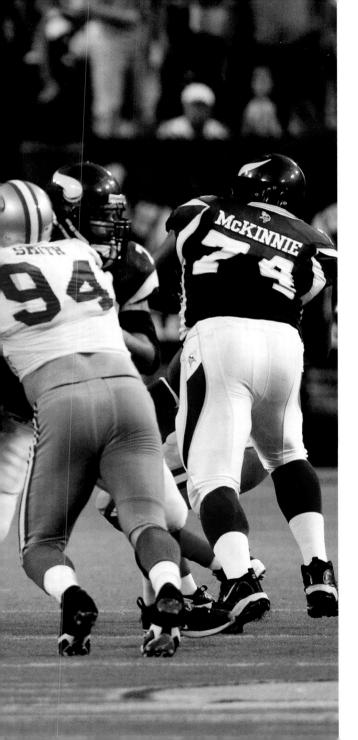

Favre to Lewis

It did not take long for Brett Favre to work his magic after coming to Minnesota in 2009. In the season's third game, Favre provided the late-game heroics he had been known for in Green Bay.

The Vikings trailed the 49ers, 24–20, late in the fourth quarter. Their offense had been sluggish for most of the game.

Minnesota took possession of the football at their own 20-yard line with 1:29 to play and no timeouts. Completions to Visanthe Shiancoe, Sidney Rice, Percy Harvin, and Bernard Berrian moved the ball to the 32-yard line with just 12 seconds on the clock.

Favre dropped back to pass, scrambled for a moment, and then fired an absolute laser to Greg Lewis at the back of the end zone. The incredible toe-tapping score was upheld by the review booth. It was Lewis's only catch of the game and one of only eight for the season.

The win, one of the most dramatic finishes in franchise history—and a play that Favre himself put in his personal top-three—was part of the Vikings' 6–0 start on their way to an appearance in the NFC Championship Game.

All-2000s Offense

QUARTERBACK: Daunte Culpepper (2000–2005). In what amounted to just over five full seasons, Culpepper threw for 20,162 yards and 135 touchdowns. Plus, he ran for another 2,470 yards and 29 touchdowns. He also made three Pro Bowl squads.

RUNNING BACKS: Adrian Peterson (2007–2009) and Michael Bennett (2001–2005). Peterson exploded onto the scene in his rookie year, rushing for more than 1,300 yards and breaking the NFL single-game mark with 296 yards on the ground. For the decade, he amassed 4,484 yards, 40 touchdowns, three Pro Bowls, and two All-Pro seasons. Bennett twice led the Vikings in rushing yards and tallied 3,174 yards, with an impressive average of 4.5 yards per carry. He earned a Pro Bowl berth in 2002.

WIDE RECEIVERS: Randy Moss (2000–2004) and Cris Carter (2000–2001). One of the most talented Vikings ever, Moss caught 425 passes for 6,416 yards and 62 touchdowns, while earning trips to three Pro Bowls along with two All-Pro nods. He led the Vikings in receptions three times and in receiving yards four times. Despite playing only two seasons, Carter still gained 2,145 yards on 169 catches and scored 15 touchdowns. He made the Pro Bowl squad in 2000.

TIGHT END: Jim Kleinsasser (2000–2009). A more explosive receiving threat, Visanthe Shiancoe could have made this list, as well, but he split his Vikings career between two decades. In comparison, Kleinsasser caught more balls in the 2000s, with 168 (for 1,523 yards receiving). More importantly, he provided punishing blocks and created matchup problems as a receiver who looked as if he could play on the offensive line.

CENTER: Matt Birk (2000–2008). Birk became the Vikings' starting center in 2000 and remained there until 2008, making 123 starts. He was named to six Pro Bowls, which is tied for the most all-time by a Vikings center.

GUARDS: Steve Hutchinson (2006–2009) and David Dixon (2000–2004). With four Pro Bowls, three All-Pro seasons, and 64 starts, Hutchinson performed at the top of his game every season in Minnesota. Dixon, a holdover from the All-1990s squad, started 77 games in the 2000s.

TACKLES: Bryant McKinnie (2002–2009) and Chris Liwienski (2000–2005). McKinnie, a first-round draft choice, made 115 starts and one Pro Bowl. After the tragic death of Korey Stringer, Liwienski filled in at tackle for two seasons before shifting to guard.

KICKER: Ryan Longwell (2006–2009). The most accurate kicker in team history, Longwell boomed 448 points through the uprights during the decade.

KICK RETURNER: Percy Harvin (2009). The Vikings had a revolving door at kick returner prior to Harvin's arrival. In his rookie year, he averaged 27.5 yards per return and took two all the way to the end zone.

—Data and statistics are for this decade only, unless otherwise noted.—

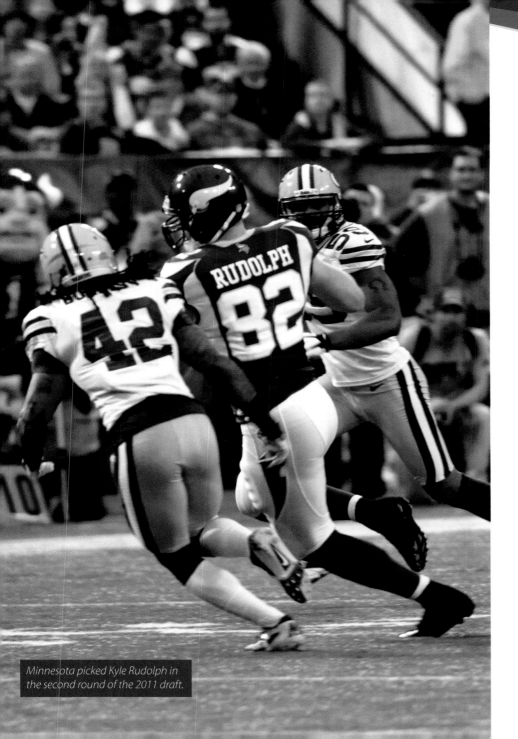

Minnesota picked Kyle Rudolph in the second round of the 2011 draft.

Starting Lineup

OFFENSE	POSITION
Christian Ponder	QB
Adrian Peterson	RB
Michael Jenkins	WR
Percy Harvin	WR
Visanthe Shiancoe	TE
Jim Kleinsasser	TE
Charlie Johnson	LT
Steve Hutchinson	LG
John Sullivan	C
Anthony Herrera	RG
Phil Loadholt	RT

DEFENSE	POSITION
Jared Allen	DE
Kevin Williams	DT
Remi Ayodele	DT
Brian Robison	DE
Erin Henderson	LB
E.J. Henderson	LB
Chad Greenway	LB
Asher Allen	CB
Cedric Griffin	CB
Jamarca Sanford	SS
Husain Abdullah	FS

SPECIAL TEAMS	POSITION
Ryan Longwell	K
Lorenzo Booker	KR
Chris Kluwe	P
Marcus Sherels	PR

Special Teams

During the Bud Grant era, one of the things that made the Vikings stand out was their tremendous special teams play. In the 1970s, the Vikings' penchant for kick-blocking contributed to their success. Matt Blair, Carl Eller, and Alan Page were the most likely to block a kick or punt, but perhaps the most famous block occurred in the 1976 NFC Championship, when Nate Allen blocked a field goal and Bobby Bryant returned it 90 yards for a score. The play helped put the team into another Super Bowl.

The Purple also enjoyed sustained success at the punter position with players like Bobby Walden, Greg Coleman, and Chris Kluwe.

In recent years, Minnesota's return men have shined. Marcus Sherels is the best punt returner in franchise history with five touchdowns. Cordarrelle Patterson ranks among the best kick returners—not just in franchise history but in NFL annals. He has the second-best yards-per-return average (29.8) in the history of the league, trailing only hall-of-famer Gale Sayers.

Percy Harvin is tied with Patterson with five total kickoffs returned for touchdowns, the most in franchise history. Harvin ranks tenth in NFL history in yards per return (27.2).

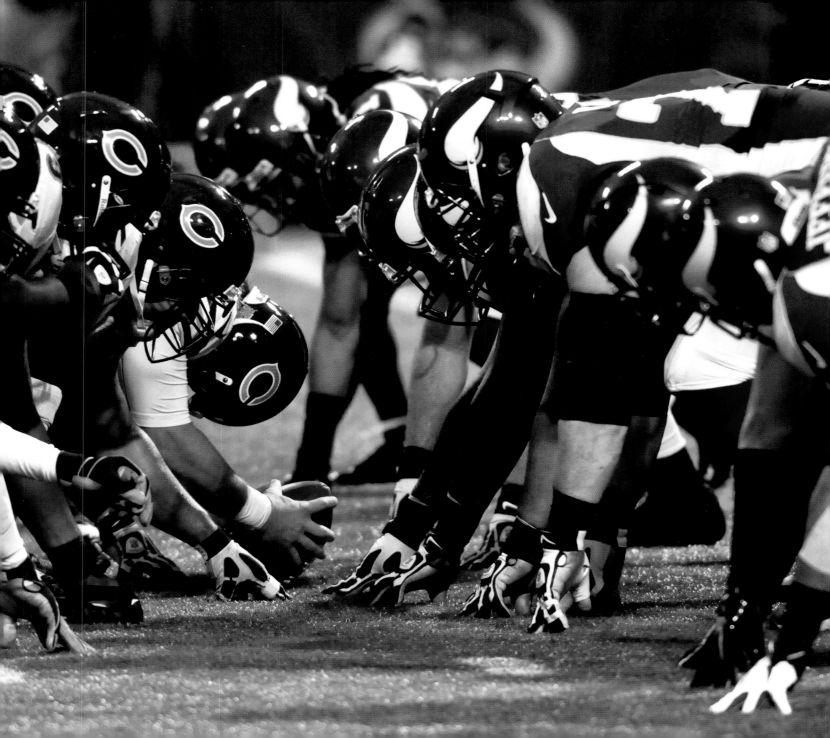

10–6
Second Place

The 2012 season represented one of the most pleasant surprises in team history. Worry about Adrian Peterson's 2011 injury was put to rest early, and he went on one of the most remarkable "runs" in NFL history. Playing on a reconstructed knee, he came within nine yards of breaking Eric Dickerson's single-season rushing record. Peterson finished with 2,097 yards. He carried home honors for NFL Most Valuable Player, NFL Offensive Player of the Year, and NFL Comeback Player of the Year.

The playoffs seemed like a long shot, but Peterson put the team on his back and carried them down the home stretch. He rushed for 154 yards and two touchdowns as the Vikings downed the Bears, 21–14. He steamrolled the Rams with 212 yards; Blair Walsh kicked five field goals, three of which were 50 yards or longer, as the Vikings beat Saint Louis, 36–22. The Texans held Peterson to a mortal 86 yards, but Walsh connected on three field goals, including a franchise-record-tying 56-yarder. Minnesota defeated Houston, 23–6. In the regular-season finale against Green Bay, Peterson smashed his way to 199 yards, including a 26-yard run with 24 seconds remaining to set up the game-winning kick. The Vikings won in dramatic fashion, 37–34.

Four straight wins earned the team a Wild Card berth. For the second time in history, the Vikings and Packers squared off in a playoff game. Joe Webb started at quarterback for the injured Christian Ponder. The offense sputtered, and the Vikings fell, 24–10.

Walsh—a rookie—set an NFL record by connecting on 10 field goals longer than 50 yards. Peterson and Walsh were named All-Pros, along with center John Sullivan.

Pro Bowl Selections

- Jared Allen (DE)
- Jerome Felton (FB)
- Chad Greenway (LB)
- Matt Kalil (T)
- Adrian Peterson (RB)
- Kyle Rudolph (TE)
- Blair Walsh (K)

Schedule

OPPONENT	SCORE	RECORD
W Jacksonville Jaguars (OT)	26–23	1–0
@ Indianapolis Colts	20–23	1–1
W San Francisco 49ers	24–13	2–1
W @ Detroit Lions	20–13	3–1
W Tennessee Titans	30–7	4–1
L @ Washington	26–38	4–2
W Arizona Cardinals	21–14	5–2
L Tampa Bay Buccaneers	17–36	5–3
L @ Seattle Seahawks	20–30	5–4
W Detroit Lions	34–24	6–4
L @ Chicago Bears	10–28	6–5
L @ Green Bay Packers	14–23	6–6
W Chicago Bears	21–14	7–6
W @ St. Louis Rams	36–22	8–6
W @ Houston Texans	23–6	9–6
W Green Bay Packers	37–34	10–6
L @ Green Bay Packers	10–24	0–1

Season Leaders

CATEGORY	TOTAL	PLAYER
Passing Yards	2,935	Christian Ponder
Rushing Yards	2,097	Adrian Peterson
Receiving Yards	677	Percy Harvin
Receptions	62	Percy Harvin
Interceptions	3	Smith/Winfield
Sacks	12	Jared Allen
Points	141	Blair Walsh

Key Additions:
Harrison Smith (draft)

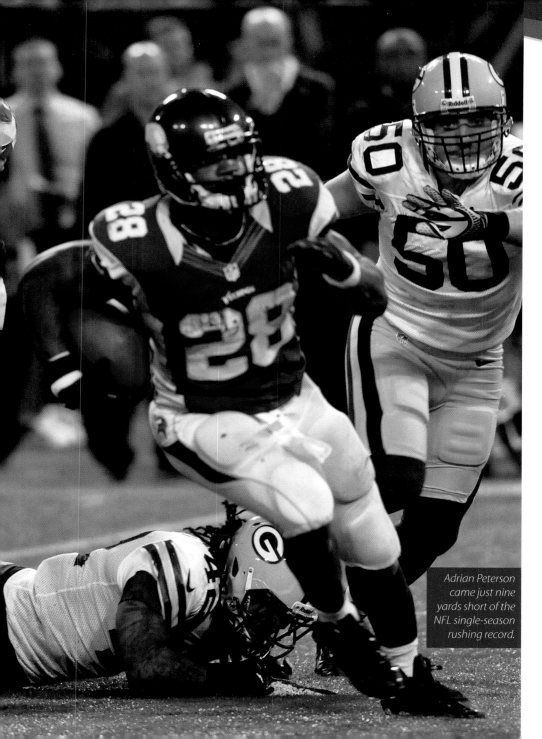

Adrian Peterson came just nine yards short of the NFL single-season rushing record.

Starting Lineup

OFFENSE	POSITION
Christian Ponder	QB
Adrian Peterson	RB
Jerome Felton	RB
Percy Harvin	WR
Michael Jenkins	WR
Kyle Rudolph	TE
Matt Kalil	LT
Charlie Johnson	LG
John Sullivan	C
Brandon Fusco	RG
Phil Loadholt	RT

DEFENSE	POSITION
Jared Allen	DE
Kevin Williams	DT
Letroy Guion	DT
Brian Robison	DE
Jasper Brinkley	LB
Erin Henderson	LB
Chad Greenway	LB
Antoine Winfield	CB
Chris Cook	CB
Jamarca Sanford	SS
Harrison Smith	FS

SPECIAL TEAMS	POSITION
Blair Walsh	K
Percy Harvin	KR
Chris Kluwe	P
Marcus Sherels	PR

5-10-1
Fourth Place

Vikings fans assumed that the team would build upon their 2012 success. Instead, what they got was a free fall. The Vikings began 0–3 and dropped to 1–7 at the midway point. The lone win came against the Steelers in a game played in London.

The second half of the campaign went a little better; the Vikings finished 4–3–1. Overall, the season proved to be a bust, as the defense ranked last in the league in points against and second to last in yards against.

The most noteworthy contest of the season came in the 11th game, at Green Bay. The Vikings led the Packers, 23–7, in the fourth quarter but surrendered 16 points to a team playing without starting quarterback Aaron Rodgers. In overtime, Green Bay kicked a field goal on their first possession, but new overtime rules (implemented in part due to the Vikings' loss to the Saints in the 2009 NFC Championship) allowed the Vikings a chance to tie or win. The Vikings added a field goal to knot the score at 26, which was how the game ended. The Vikings and Packers became the only teams since overtime was added in 1974 to tie each other twice (10–10 in 1978), and the Vikings became the first team in NFL history to not lose a game after surrendering points in overtime.

The 2013 season also produced one of the wildest games in franchise history. Playing in the snow, on the road in Baltimore, the Vikings trailed the Ravens, 7–6, at the start of the fourth quarter. From there, the teams combined for an additional 42 points (the most points in any quarter in franchise history), including 36 of them in the final 2:05. Of the five touchdowns in that span, there was a 41-yard run, a 77-yard kickoff return, and a 79-yard screen pass for a touchdown. The Ravens won on a nine-yard pass with four seconds to play.

Following the season, the Vikings parted ways with head coach Leslie Frazier. He finished in Minnesota with a .398 winning percentage.

Rookie wide receiver Cordarrelle Patterson flashed plenty of potential and earned All-Pro honors as a kick returner.

Schedule

OPPONENT	SCORE	RECORD
@ Detroit Lions	24–34	0–1
@ Chicago Bears	30–31	0–2
Cleveland Browns	27–31	0–3
W Pittsburgh Steelers	34–27	1–3
Carolina Panthers	10–35	1–4
@ New York Giants	7–23	1–5
Green Bay Packers	31–44	1–6
@ Dallas Cowboys	23–27	1–7
W Washington	34–27	2–7
@ Seattle Seahawks	20–41	2–8
T @ Green Bay Packers (OT)	26–26	2–8–1
W Chicago Bears (OT)	23–20	3–8–1
@ Baltimore Ravens	26–29	3–9–1
W Philadelphia Eagles	48–30	4–9–1
@ Cincinnati Bengals	14–42	4–10–1
W Detroit Lions	14–13	5–10–1

Season Leaders

CATEGORY	TOTAL	PLAYER
Passing Yards	1,807	Matt Cassel
Rushing Yards	1,266	Adrian Peterson
Receiving Yards	804	Greg Jennings
Receptions	68	Greg Jennings
Interceptions	3	Chad Greenway
Sacks	11.5	Jared Allen
Points	121	Blair Walsh

Key Additions:
Xavier Rhodes (draft)

Starting Lineup

Jerome Simpson WR CB Josh Robinson

Matt Kalil LT DE Jared Allen

Adrian Peterson RB

Charlie Johnson LG DT Kevin Williams LB Marvin Mitchell

Christian Ponder QB John Sullivan C DT Letroy Guion LB Erin Henderson SS Jamarca Sanford

Brandon Fusco RG FS Andrew Sendejo

Jerome Felton RB Phil Loadholt RT DE Brian Robison LB Chad Greenway

Kyle Rudolph TE

K Blair Walsh
KR Jeff Locke
P Cordarrelle Patterson
PR Marcus Sherels

Greg Jennings WR CB Chris Cook

Pro Bowl Selections

- Cordarrelle Patterson (KR)
- Adrian Peterson (RB)

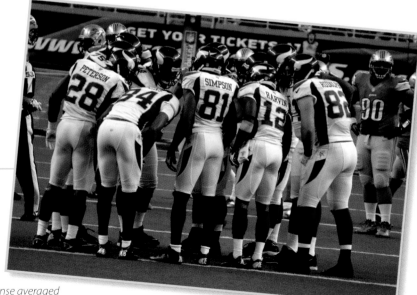

The Vikings offense averaged 24.4 points per game in 2013.

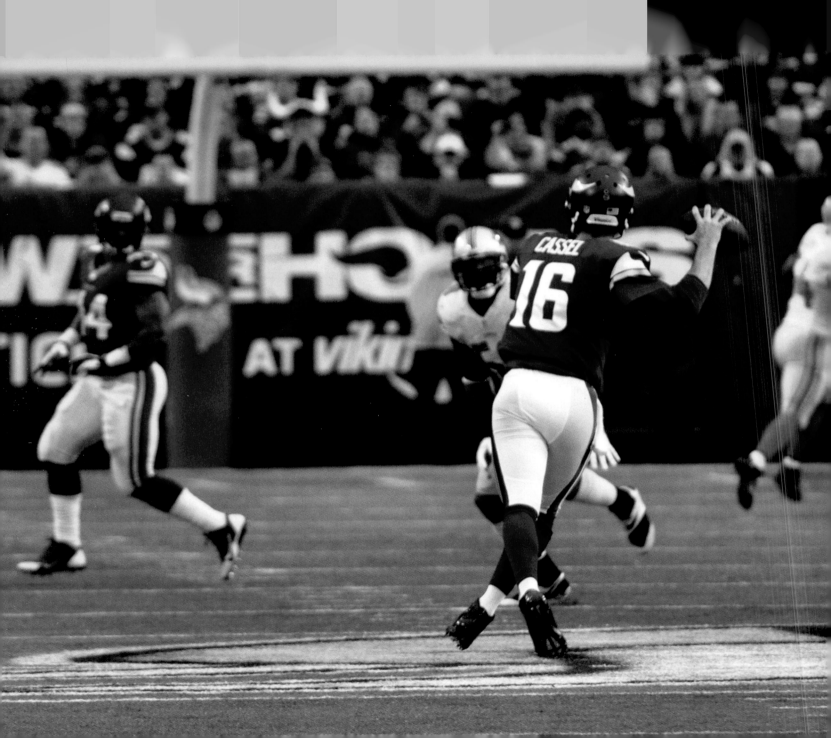

Quarterback Carousel

Matt Cassel was one of more than 25 quarterbacks to start a game for the Vikings between 1988 and 2018. From the time Tommy Kramer undisputedly held the spot in the early to mid-1980s, the Vikings struggled to find lasting consistency at the most important position in football.

Whether due to injuries, age, inefficient play, or a combination of these factors, more than two dozen signal callers saw their careers with the team derailed. Even when the quest for a field general appeared complete—with the emergence of players like Daunte Culpepper and Teddy Bridgewater—devastating injuries forced the Vikings to seek alternative plans. Talented stop-gap veterans such as Warren Moon, Randall Cunningham, and Brett Favre did not provide long-term solutions, nor did high draft picks like Tarvaris Jackson and Christian Ponder.

In 2020, Kirk Cousins became the team's first quarterback since Culpepper to start at least 14 games in three straight seasons.

7–9
Third Place

Mike Zimmer became the Vikings' ninth head coach after Leslie Frazier's dismissal, and the team began playing their home games at the University of Minnesota's TCF Bank Stadium as they awaited completion of U.S. Bank Stadium.

Zimmer began the rebuilding process by adding physical defensive players such as Anthony Barr through the draft and Linval Joseph via free agency. On the offensive side, Teddy Bridgewater joined Tommy Kramer, Daunte Culpepper, and Christian Ponder as the only quarterbacks drafted by the franchise in the first round. Bridgewater became the starter after Matt Cassel was injured in a Week 3 loss to the Saints.

Later in the season, the Vikings snapped long losing streaks against two franchises. A victory over the Buccaneers in overtime, on Barr's fumble-recovery return for a touchdown, marked Minnesota's first win versus Tampa Bay in 13 years. The Vikings also defeated the Jets in an overtime thriller, won on Jarius Wright's 87-yard touchdown reception. That victory broke a 39-year drought.

The second-to-last game of the season saw a wild fourth quarter finish. When it began, the Vikings led the Dolphins, 17–14. The teams traded scores, back and forth, until the Dolphins tied the game, 35–35, with just over a minute to play. The Vikings offense sputtered and was forced to punt. But the Dolphins blocked Jeff Locke's punt for a safety, which proved to be the winning score.

The Vikings played respectable football throughout 2014, even after losing All-Pro Adrian Peterson for 15 games due to a suspension under the NFL's personal-conduct policy. With coaching and personnel changes, the franchise laid the groundwork for greater success in the future.

Pro Bowl Selections

- None

Schedule

OPPONENT	SCORE	RECORD
W @ St. Louis Rams	34–6	1–0
New England Patriots	7–30	1–1
@ New Orleans Saints	9–20	1–2
W Atlanta Falcons	41–28	2–2
@ Green Bay Packers	10–42	2–3
Detroit Lions	3–17	2–4
@ Buffalo Bills	16–17	2–5
W @ Tampa Bay (OT)	19–13	3–5
W Washington	29–26	4–5
@ Chicago Bears	13–21	4–6
Green Bay Packers	21–24	4–7
W Carolina Panthers	31–13	5–7
W New York Jets (OT)	30–24	6–7
@ Detroit Lions	14–16	6–8
@ Miami Dolphins	35–37	6–9
W Chicago Bears	13–9	7–9

Season Leaders

CATEGORY	TOTAL	PLAYER
Passing Yards	2,919	Teddy Bridgewater
Rushing Yards	570	Matt Asiata
Receiving Yards	742	Greg Jennings
Receptions	59	Greg Jennings
Interceptions	5	Harrison Smith
Sacks	12	Everson Griffen
Points	107	Blair Walsh

Key Additions:
Anthony Barr (draft)
Adam Thielen (free agent)

Starting Lineup

OFFENSE	POSITION
Christian Ponder	QB
Matt Asiata	RB
Cordarrelle Patterson	WR
Greg Jennings	WR
Kyle Rudolph	TE
Rhett Ellison	TE
Matt Kalil	LT
Charlie Johnson	LG
John Sullivan	C
Joe Berger	RG
Phil Loadholt	RT

DEFENSE	POSITION
Everson Griffen	DE
Sharrif Floyd	DT
Linval Joseph	DT
Brian Robison	DE
Anthony Barr	LB
Jasper Brinkley	LB
Chad Greenway	LB
Captain Munnerlyn	CB
Xavier Rhodes	CB
Robert Blanton	SS
Harrison Smith	FS

SPECIAL TEAMS	POSITION
Blair Walsh	K
Cordarrelle Patterson	KR
Jeff Locke	P
Marcus Sherels	PR

Carl Eller commented on his experiences playing in winter conditions: "It was all Bud [Grant]'s idea. He said, 'You're going to be cold, so you've just got to play through it and not think about it.' Physically, we were just as cold as [our opponents]. Psychologically, we'd rather not dwell on that. We had to win the game."

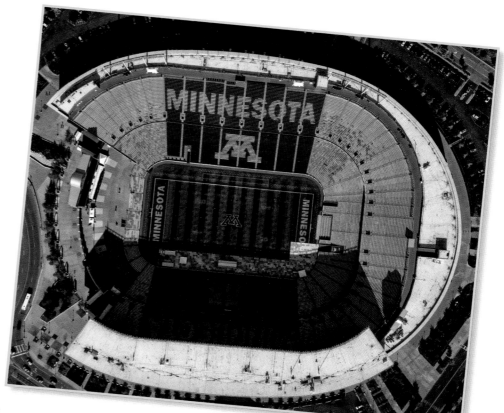

The Vikings called TCF Bank Stadium home in 2014 and 2015.

2015

11–5
First Place

The Vikings took a sizable and somewhat unexpected leap forward in 2015, becoming NFC North champions in Mike Zimmer's second year as head coach.

After a sluggish start, the team enjoyed a five-game winning streak and then closed out the year with three wins in a row, including a division-clinching 20–13 victory in the season's final game at Green Bay.

However, the Vikings' season ended with a devastating loss to Seattle in the postseason. In brutal conditions, with wind chills that plunged to -25, the Vikings did battle. After three quarters, they held a 9–0 advantage. Seattle scored a touchdown early in the fourth, and they added a field goal following a fumble by Adrian Peterson. Just like that, midway through the fourth quarter, in a game the Vikings had dominated, they trailed, 10–9.

The teams traded punts a couple of times, and the Vikings took possession at their own 39-yard line with 1:42 to go. The offense put together an impressive drive, moving all the way to the nine-yard line with just 26 seconds left. Blair Walsh trotted onto the field, having connected on three kicks—two of which exceeded 40 yards. But Walsh missed the 27-yarder wide left, and the Vikings season ended with abruptness.

Under the guidance of Zimmer, a defensive wizard, Minnesota's remade defense (which ranked last in scoring in 2013) jumped to fifth best.

The Vikings drafted several players who made an early impact, including cornerback Trae Waynes in the first round, linebacker Eric Kendricks in the second, defensive end Danielle Hunter in the third, and wide receiver Stefon Diggs in the fifth.

Cordarrelle Patterson and Adrian Peterson made the All-Pro squad.

Pro Bowl Selections

- Anthony Barr (LB)
- Teddy Bridgewater (QB)
- Everson Griffen (DE)
- Adrian Peterson (RB)
- Harrison Smith (S)

Schedule

OPPONENT	SCORE	RECORD
@ San Francisco 49ers	3–20	0–1
W Detroit Lions	26–16	1–1
W San Diego Chargers	31–14	2–1
@ Denver Broncos	20–23	2–2
W Kansas City Chiefs	16–10	3–2
W @ Detroit Lions	28–19	4–2
W @ Chicago Bears	23–20	5–2
W St. Louis Rams (OT)	21–18	6–2
W @ Oakland Raiders	30–14	7–2
Green Bay Packers	13–30	7–3
W @ Atlanta Falcons	20–10	8–3
Seattle Seahawks	7–38	8–4
@ Arizona Cardinals	20–23	8–5
W Chicago Bears	38–17	9–5
W New York Giants	49–17	10–5
W @ Green Bay Packers	20–13	11–5
Seattle Seahawks	9–10	0–1

Season Leaders

CATEGORY	TOTAL	PLAYER
Passing Yards	3,231	Teddy Bridgewater
Rushing Yards	1,485	Adrian Peterson
Receiving Yards	720	Stefon Diggs
Receptions	52	Stefon Diggs
Interceptions	3	Terence Newman
Sacks	10.5	Everson Griffen
Points	135	Blair Walsh

Key Additions:
Stefon Diggs (draft)
Danielle Hunter (draft)
Eric Kendricks (draft)

Starting Lineup

OFFENSE	POSITION
Teddy Bridgewater	QB
Adrian Peterson	RB
Mike Wallace	WR
Stefon Diggs	WR
Kyle Rudolph	TE
Rhett Ellison	TE
Matt Kalil	LT
Brandon Fusco	LG
Joe Berger	C
Mike Harris	RG
T.J. Clemmings	RT

DEFENSE	POSITION
Everson Griffen	DE
Sharrif Floyd	DT
Linval Joseph	DT
Brian Robison	DE
Anthony Barr	LB
Eric Kendricks	LB
Chad Greenway	LB
Terence Newman	CB
Xavier Rhodes	CB
Andrew Sendejo	SS
Harrison Smith	FS

SPECIAL TEAMS	POSITION
Blair Walsh	K
Cordarrelle Patterson	KR
Jeff Locke	P
Marcus Sherels	PR

"I want to fit our scheme to the players to the best of their abilities. Like I said before, it really does not matter if it is a three-four or a four-three [defense], and as far as my philosophy, I want to stop the run and I want to hit the quarterback."

—Mike Zimmer, 2014

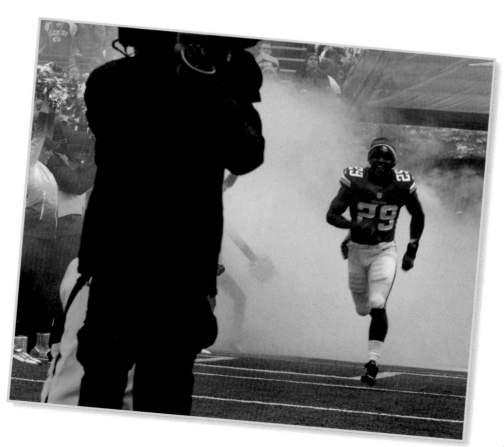

Xavier Rhodes developed into one of the league's best cornerbacks.

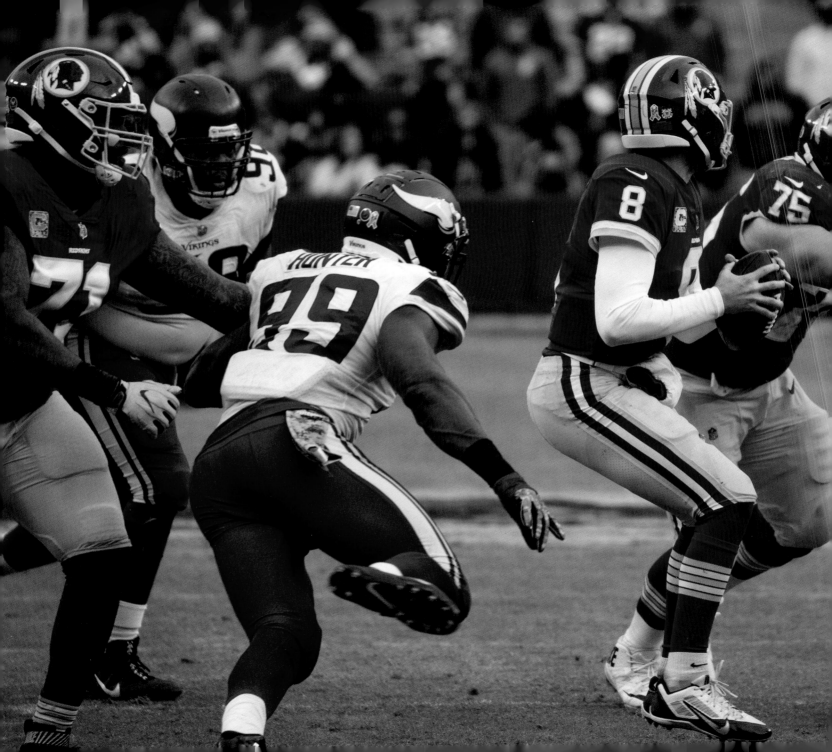

Starting Lineup

OFFENSE	POSITION
Sam Bradford	QB
Jerick McKinnon	RB
Adam Thielen	WR
Cordarrelle Patterson	WR
Stefon Diggs	WR
Kyle Rudolph	TE
T.J. Clemmings	LT
Alex Boone	LG
Joe Berger	C
Brandon Fusco	RG
Jeremiah Sirles	RT

DEFENSE	POSITION
Everson Griffen	DE
Shamar Stephen	DT
Linval Joseph	DT
Brian Robison	DE
Anthony Barr	LB
Eric Kendricks	LB
Chad Greenway	LB
Terence Newman	CB
Xavier Rhodes	CB
Andrew Sendejo	SS
Harrison Smith	FS

SPECIAL TEAMS	POSITION
Kai Forbath	K
Cordarrelle Patterson	KR
Jeff Locke	P
Marcus Sherels	PR

The Vikings moved into their beautiful new home, U.S. Bank Stadium, in 2016.

13–3
First Place

The 2017 season felt different, until it didn't. The Vikings were not a dominating force, although their defense finished first in yards, points, and third-down conversions allowed. Yet it somehow seemed as if this might finally be the year; it did not seem too good to be true.

The season began with one of Sam Bradford's finest performances as a professional quarterback in a convincing win over the Saints. The following week, a knee flare-up caused him to be a game-time scratch. The injury lingered; Bradford was not able to play effectively for the rest of the year.

From that point on, Case Keenum played in every game—and he played like one of the top quarterbacks in the NFL. His rags-to-riches ascent provided one of the best stories of the football season.

As the Vikings entered the playoffs, they seemed like a pretty good bet to represent the NFC in the Super Bowl. After racing to a 17–0 lead over the Saints in the divisional round, the Vikings found themselves trailing, 24–23, with 10 seconds to play. And then the Minneapolis Miracle happened. (See page 162.) Stefon Diggs caught Keenum's pass and scampered 61 yards to the end zone. The Vikings had finally won a big game in which they were on the winning side of the heartbreak.

The NFC Championship was a different story. After letting Minnesota march down the field to grab a 7–0 lead, Philadelphia (led by their own backup quarterback, Nick Foles) outscored the Vikings 38–0 the rest of the way. It was another crushing end to a promising season.

Everson Griffen, Xavier Rhodes and Harrison Smith were named All-Pro.

Pro Bowl Selections

- Anthony Barr (LB)
- Everson Griffen (DE)
- Linval Joseph (DT)
- Xavier Rhodes (CB)
- Kyle Rudolph (TE)
- Harrison Smith (S)
- Adam Thielen (WR)

Schedule

OPPONENT	SCORE	RECORD
W New Orleans Saints	29–19	1–0
@ Pittsburgh Steelers	9–26	1–1
W Tampa Bay Buccaneers	34–17	2–1
Detroit Lions	7–14	2–2
W @ Chicago Bears	20–17	3–2
W Green Bay Packers	23–10	4–2
W Baltimore Ravens	24–16	5–2
W Cleveland Browns (@ London)	33–16	6–2
W @ Washington	38–30	7–2
W St. Louis Rams	24–7	8–2
W @ Detroit Lions	30–23	9–2
W @ Atlanta Falcons	14–9	10–2
@ Carolina Panthers	24–31	10–3
W Cincinnati Bengals	34–7	11–3
W @ Green Bay Packers	16–0	12–3
W Chicago Bears	23–10	13–3
W *New Orleans Saints*	*29–24*	*1–0*
@ Philadelphia Eagles	*7–38*	*1–1*

Season Leaders

CATEGORY	TOTAL	PLAYER
Passing Yards	3,547	Case Keenum
Rushing Yards	842	Latavius Murray
Receiving Yards	1,276	Adam Thielen
Receptions	91	Adam Thielen
Interceptions	5	Harrison Smith
Sacks	13	Everson Griffen
Points	130	Kai Forbath

Key Additions:
Dalvin Cook (draft)

Starting Lineup

OFFENSE	POSITION
Case Keenum	QB
Latavius Murray	RB
Adam Thielen	WR
Laquon Treadwell	WR
Stefon Diggs	WR
Kyle Rudolph	TE
Riley Reiff	LT
Nick Easton	LG
Pat Elflein	C
Joe Berger	RG
Mike Remmers	RT

DEFENSE	POSITION
Everson Griffen	DE
Tom Johnson	DT
Linval Joseph	DT
Danielle Hunter	DE
Anthony Barr	LB
Eric Kendricks	LB
Trae Waynes	CB
Xavier Rhodes	CB
Terence Newman	CB
Andrew Sendejo	SS
Harrison Smith	FS

SPECIAL TEAMS	POSITION
Kai Forbath	K
Jerick McKinnon	KR
Ryan Quigley	P
Marcus Sherels	PR

Minnesota's offense was powered by Stefon Diggs, Case Keenum, and Adam Thielen.

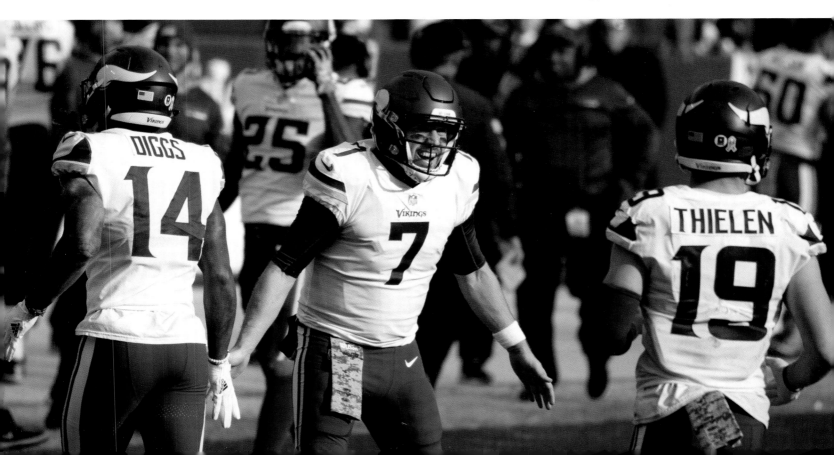

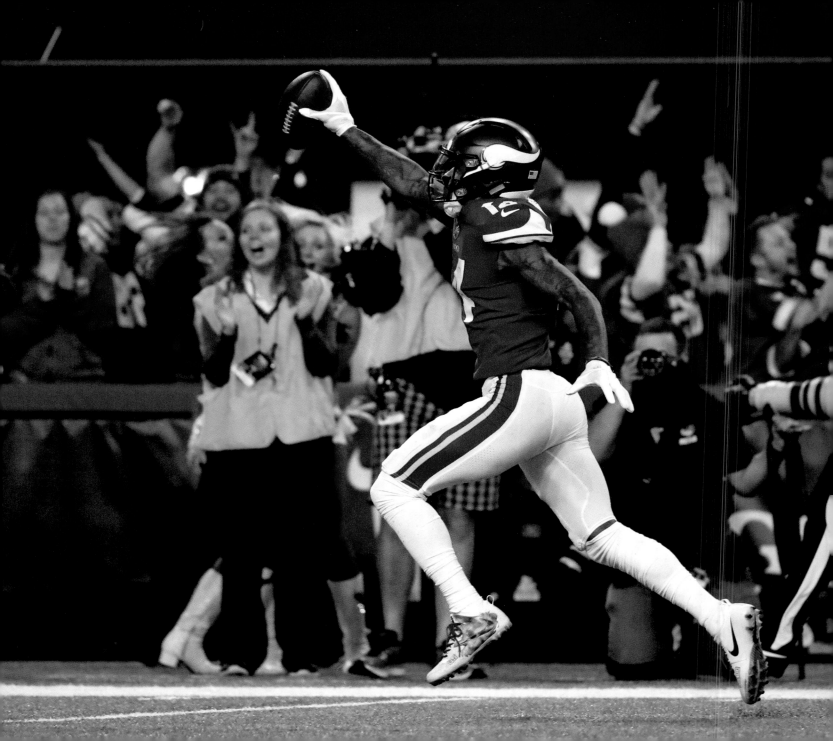

The Minneapolis Miracle

The Saints and Vikings have played some dramatic postseason contests, but none of them had the jaw-dropping finish of the game that followed the 2017 season.

The Vikings staked a 17–0 lead at halftime but saw it evaporate in the second half. The Saints took their own 21–20 advantage with three minutes to play in the game.

Vikings kicker Kai Forbath nailed a 51-yard field goal, and Minnesota retook the lead with 1:29 on the clock. The Saints' drive that followed used 11 plays to travel 50 yards in 1:04. When Will Lutz kicked a 43-yard field goal with 25 seconds to go, a 24–23 victory looked clinched for New Orleans.

Starting at their own 25-yard line, with no timeouts, the Vikings first endured a five-yard false start penalty. But quarterback Case Keenum completed a 19-yard pass to Stefon Diggs for a first down.

Two incomplete passes followed, and 10 seconds remained. The Vikings were hoping for a completion deep enough to set up a field goal but close enough to a sideline for the receiver to get out of bounds, in order to stop the clock. Playing against a defense aligned against deep sideline passes, the odds were dramatically against the Vikings.

That's when Minnesota created the most unforgettable moment in franchise history. Keenum threw a deep ball to Diggs on the sideline. Saints defender Marcus Williams missed the tackle. Diggs balanced himself on the turf with his left hand and then sprinted, untouched, 61-yards to the end zone and to a 29–24 win for the Vikings.

8-7-1
Second Place

The 2018 season began with very high expectations but ended with disappointment. The Vikings proved once again that pursuing the final "missing piece" of a championship-ready team is rarely as simple as it sounds.

The organization spent handsomely on free-agent quarterback Kirk Cousins, only to see subpar offensive line play—and overall inconsistency—derail what many believed would be a team that contended for the Super Bowl.

In the season's second game, the Vikings posted their third tie against the Packers (the most that two opponents have tied each other since the NFL changed its overtime rules in 1974). Three missed field goals in the game—including two misses in overtime—led to the release of rookie kicker Daniel Carlson.

The heavily-favored Vikings suffered a disastrous loss to the Bills at home. The next week, they played in Los Angeles on a Thursday night matchup against the Rams. Quarterback Jared Goff scorched the Vikings for 465 yards passing and five touchdowns in a thrilling 38–31 victory over Minnesota.

A win against the Eagles, in a rematch of the previous season's NFC Championship, kicked off a three-game winning streak to steady the ship.

The Vikings set a team record by sacking Detroit's quarterback Matthew Stafford 10 times in their 24–9 mauling of the Lions.

Following a 24–17 win against the Packers, the Vikings fell to the Patriots and Seahawks—and scored a combined 17 points in the two games. This prompted the firing of offensive coordinator John DeFilippo.

The next week, the Vikings offense raced to 41 points and 418 total yards, with 220 of those coming on the ground. However, the Vikings continued their inconsistent play down the stretch and stumbled against the Bears, 24–10, in the season finale—a loss that kept the Purple out of the playoffs.

Cousins passed for 4,298 yards, the second-best mark in the franchise's history. Adam Thielen's 113 catches were the third-most in team history. Danielle Hunter was named All-Pro.

Schedule

OPPONENT	SCORE	RECORD
W San Francisco 49ers	24–16	1–0
T @ Green Bay Packers (OT)	29–29	1–0–1
L Buffalo Bills	6–27	1–1–1
L @ Los Angeles Rams	31–38	1–2–1
W @ Philadelphia Eagles	23–21	2–2–1
W Arizona Cardinals	27–17	3–2–1
W @ New York Jets	37–17	4–2–1
L New Orleans Saints	20–30	4–3–1
W Detroit Lions	24–9	5–3–1
L @ Chicago Bears	20–25	5–4–1
W Green Bay Packers	24–17	6–4–1
L @ New England Patriots	10–24	6–5–1
L @ Seattle Seahawks	7–21	6–6–1
W Miami Dolphins	41–17	7–6–1
W @ Detroit Lions	27–9	8–6–1
L Chicago Bears	10–24	8–7–1

Season Leaders

CATEGORY	TOTAL	PLAYER
Passing Yards	4,298	Kirk Cousins
Rushing Yards	615	Dalvin Cook
Receiving Yards	1,373	Adam Thielen
Receptions	113	Adam Thielen
Interceptions	3	Smith/Harris
Sacks	14.5	Danielle Hunter
Points	93	Dan Bailey

Key Additions:
Kirk Cousins (free agent)
Brian O'Neill (draft)

Starting Lineup

Adam Thielen 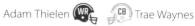 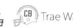 Trae Waynes

Laquon Treadwell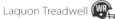

Riley Reiff Everson Griffen

Dalvin Cook

Tom Compton Sheldon Richardson

Anthony Barr

Kirk Cousins Pat Elflein Eric Kendricks

Anthony Harris

Mike Remmers Linval Joseph

Harrison Smith

Ben Gedeon

Brian O'Neill Danielle Hunter

Kyle Rudolph

K Dan Bailey
KR Ameer Abdullah
P Matt Wile
PR Marcus Sherels

Stefon Diggs Xavier Rhodes

Pro Bowl Selections

- Anthony Barr (LB)
- Danielle Hunter (DE)
- Harrison Smith (S)
- Adam Thielen (WR)

Harrison Smith was named to the Pro Bowl in 2015–2019.

10–6
Second Place

The 2019 season got off to a mediocre start. After four games, the Vikings sat with wins against the Falcons and Raiders and ugly losses versus the Packers and Bears.

Minnesota then went on a four-game winning streak, raising their record to 6–2. They played .500 football for the remainder of the season and clinched a playoff berth.

In Week 11, the Vikings faced a Denver team that was 3–6. The Broncos dominated the first half on both sides of the ball and stormed to a 20–0 lead. But Minnesota controlled the second half, scoring touchdowns on all four of their possessions. The game came down to the final seconds. Denver, trailing 27–23, drove to the Vikings' four-yard line. But Minnesota's defense forced an incompletion as time expired, and the Vikings held on for the win.

When the regular season came to its conclusion, the 13–3 Saints—a team many Vikings fans wanted to avoid—became Minnesota's opponent in the Wild Card round.

After the Minneapolis Miracle two years earlier, most experts figured the revenge-seeking Saints would steamroll the Purple. However, the Vikings jumped to a 20–10 advantage. Of course, no fan thought the lead was safe. The Saints tied the score on a 49-yard field goal near the end of regulation. After the Vikings took possession of the ball in overtime, Cousins dropped a beautiful 43-yard pass to Adam Thielen that put the offense at the four-yard line. Two runs netted the Vikings minus two yards. On third down, Cousins hit Kyle Rudolph for a game-winning score. Minnesota ended the Saints' season for the second time in three years.

The following week in San Francisco, the 49ers manhandled the Vikings on both sides of the line of scrimmage and posted a 27–10 win.

Pro Bowlers for Minnesota included Dalvin Cook, Kirk Cousins, Everson Griffen, Danielle Hunter, Eric Kendricks, Xavier Rhodes, and Harrison Smith. Kendricks also received an All-Pro nod.

Schedule

	OPPONENT	SCORE	RECORD
W	Atlanta Falcons	28–12	1–0
L	@ Green Bay Packers	16–21	1–1
W	Oakland Raiders	34–14	2–1
L	@ Chicago Bears	6–16	2–2
W	@ New York Giants	28–10	3–2
W	Philadelphia Eagles	38–20	4–2
W	@ Detroit Lions	42–30	5–2
W	Washington	19–9	6–2
L	@ Kansas City Chiefs	23–26	6–3
W	@ Dallas Cowboys	28–24	7–3
W	Denver Broncos	27–23	8–3
L	@ Seattle Seahawks	30–37	8–4
W	Detroit Lions	20–7	9–4
W	@ Los Angeles Chargers	39–10	10–4
L	Green Bay Packers	10–23	10–5
L	Chicago Bears	19–21	10–6
W	@ New Orleans Saints (OT)	26–20	1–0
L	@ San Francisco 49ers	10–27	1–1

Season Leaders

CATEGORY	TOTAL	PLAYER
Passing Yards	3,603	Kirk Cousins
Rushing Yards	1,135	Dalvin Cook
Receiving Yards	1,130	Stefon Diggs
Receptions	63	Stefon Diggs
Interceptions	6	Anthony Harris
Sacks	14.5	Danielle Hunter
Points	121	Dan Bailey

Key Additions:
Garrett Bradbury (draft)
Irv Smith, Jr. (draft)

Starting Lineup

Adam Thielen WR CB Trae Waynes

Riley Reiff LT DE Everson Griffen

Dalvin Cook RB

LB Anthony Barr

Pat Elflein LG DT Shamar Stephen

Kirk Cousins QB Garrett Bradbury C

LB Eric Kendricks

SS Harrison Smith

DT Linval Joseph

C.J. Ham RB

Josh Kline RG

LB Ben Gedeon

FS Anthony Harris

Brian O'Neill RT DE Danielle Hunter

Kyle Rudolph TE

K Dan Bailey
KR Ameer Abdullah
P Britton Colquitt
PR Mike Hughes

Stefon Diggs WR CB Xavier Rhodes

Pro Bowl Selections

- Dalvin Cook (RB)
- Kirk Cousins (QB)
- Everson Griffen (DE)
- C.J. Ham (RB)

- Danielle Hunter (DE)
- Eric Kendricks (LB)
- Xavier Rhodes (CB)
- Harrison Smith (S)

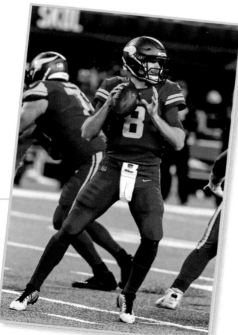

Kirk Cousins had a 107.4 quarterback rating in 2019.

2020

7–9
Third Place

To paraphrase legendary head coach Bill Parcels, the Vikings' record was who they were. Some fans might look at the 7–9 record and see one-point losses to playoff teams Tennessee and Seattle, as well as a three-point loss to the Cowboys, and think the Vikings could have been 10–6. Other fans might look at the shaky wins against Carolina, Jacksonville, and Detroit and think the team could have been 4–12.

Minnesota experienced a significant personnel overhaul, cutting ties with a handful of defensive veterans and losing others for substantial portions of the season to injury.

The year's highlight was a 28–22 victory over Green Bay at Lambeau Field, which came when the Vikings were just 1–5. Dalvin Cook scored a franchise-record-tying four touchdowns in the game. The win spawned a hot streak, and the Vikings got to 6–6 with a victory over Jacksonville. But the team finished the season with three losses in four games.

The offense proved to be a revelation, with Dalvin Cook solidifying his status as one of the best runners in the game. He finished the season with 1,557 rushing yards (third most in franchise history) and 17 total touchdowns. He enjoyed a 206-yard rushing effort against Detroit, with 46 yards receiving that made it the fourth biggest yardage day in Vikings history.

Quarterback Kirk Cousins tossed the second-most touchdowns (35) in franchise history. His 4,265 passing yards ranked third behind his 2018 campaign and Daunte Culpepper's 2004 total.

Rookie defensive back Cameron Dantzler experienced a few growing pains but showed great promise in an overhauled secondary. The same could be said for defensive lineman D.J. Wonnum. Second-round pick Ezra Cleveland also flashed potential, starting nine games on the offensive line. But no newcomer did more than first-rounder Justin Jefferson, who grabbed 88 receptions for a (post-merger) rookie-record 1,400 yards.

Cook and Jefferson earned Pro Bowl honors. Cook was also All-Pro.

Schedule

OPPONENT	SCORE	RECORD
Green Bay Packers	34–43	0–1
@ Indianapolis Colts	11–28	0–2
Tennessee Titans	30–31	0–3
W @ Houston Texans	31–23	1–3
@ Seattle Seahawks	26–27	1–4
Atlanta Falcons	23–40	1–5
W @ Green Bay Packers	28–22	2–5
W Detroit Lions	34–20	3–5
W @ Chicago Bears	19–13	4–5
Dallas Cowboys	28–31	4–6
W Carolina Panthers	28–27	5–6
W Jacksonville Jaguars (OT)	27–24	6–6
@ Tampa Bay Buccaneers	14–26	6–7
Chicago Bears	27–33	6–8
@ New Orleans Saints	33–52	6–9
W @ Detroit Lions	37–35	7–9

Season Leaders

CATEGORY	TOTAL	PLAYER
Passing Yards	4,265	Kirk Cousins
Rushing Yards	1,557	Dalvin Cook
Receiving Yards	1,400	Justin Jefferson
Receptions	88	Justin Jefferson
Interceptions	5	Harrison Smith
Sacks	5	Yannick Ngakoue
Points	108	Dalvin Cook

Key Additions:
Ezra Cleveland (draft)
Cameron Dantzler (draft)
Justin Jefferson (draft)

Starting Lineup

Justin Jefferson finished second in Rookie of the Year voting in 2020.

Adam Thielen (WR) — (CB) Cameron Dantzler

Riley Reiff (LT) — (DE) Yannick Ngakoue

Dalvin Cook (RB)

Dakota Dozier (LG) — (DT) Shamar Stephen — (LB) Troy Dye

Kirk Cousins (QB) — Garrett Bradbury (C) — (LB) Eric Kendricks — (SS) Harrison Smith

Ezra Cleveland (RG) — (DT) Jaleel Johnson — (FS) Anthony Harris

C.J. Ham (RB) — (LB) Eric Wilson

Brian O'Neill (RT) — (DE) Ifeadi Odenigbo

Kyle Rudolph (TE)

K Dan Bailey
KR Ameer Abdullah
P Britton Colquitt
PR Chad Beebe

Justin Jefferson (WR) — (CB) Jeff Gladney

Vikings Record

Most Consecutive 100-Yard Receiving Games:
Adam Thielen: 8 games (2018)

Pro Bowl Selections

- Dalvin Cook (RB)
- Justin Jefferson (WR)

Rookie Record
for Jefferson

2020

All-2010s Offense

QUARTERBACK: Kirk Cousins (2018–2019). No Vikings quarterback achieved any sort of sustained success during the decade. In just two seasons, Cousins emerged as the best of a pack that included Teddy Bridgewater and Sam Bradford. Cousins passed for 7,901 yards and 56 touchdowns. He made the 2019 Pro Bowl.

RUNNING BACKS: Adrian Peterson (2010–2016) and Dalvin Cook (2017–2019). Peterson continued to dominate in the 2010s, racking up 7,263 rushing yards and 57 touchdowns. His accolades included four Pro Bowls, two All-Pro selections, one MVP, and a spot on the NFL All-Decade team. He led the team in rushing five times. Drafted to replace the irreplaceable Peterson, Cook did very well in his own right with 2,104 yards rushing, 17 touchdowns, one Pro Bowl, and the team lead in rushing twice.

WIDE RECEIVERS: Adam Thielen (2014–2019) and Stefon Diggs (2015–2019). Thielen grabbed 323 passes for 4,315 yards and scored 25 touchdowns. He appeared in two Pro Bowls, and he led the team in receptions twice and receiving yards three times. Pairing with Thielen as one of the NFL's top receiving duos, Diggs hauled in 365 balls, gaining 4,623 yards and scoring 30 touchdowns. He led the team in catches three times and in receiving yards twice. He scored the touchdown that became the Minneapolis Miracle.

TIGHT END: Kyle Rudolph (2011–2019). Rudolph tallied 425 receptions, 4,154 receiving yards, and 47 touchdowns. He also made two Pro Bowl appearances and earned MVP of the game once.

CENTER: John Sullivan (2010–2014). With 77 starts at center, Sullivan was the most prolific player at this position during the decade.

GUARDS: Joe Berger (2011–2017) and Charlie Johnson (2011–2014). Berger toggled back and forth between guard and center but made 34 starts at guard. Johnson also moved along the line, playing tackle initially before making 45 starts at the interior position.

TACKLES: Phil Loadholt (2010–2014) and Matt Kalil (2012–2016). Loadholt made 74 starts at right tackle before an injury brought his career to a premature end. Kalil earned Pro Bowl honors as a rookie and made 66 starts at left tackle.

KICKER: Blair Walsh (2012–2016). When Walsh was good, he was really good. Fans sometimes forget that Walsh was an All-Pro and Pro Bowler his rookie year, when he kicked 10 field goals of 50 yards or more. He scored 555 points while in purple during the 2010s.

KICK RETURNER: Cordarrelle Patterson (2013–2016). The greatest kick returner in franchise history, Patterson made the Pro Bowl twice, the All-Pro squad twice, averaged more than 30 yards per return, and scored five touchdowns.

—Data and statistics are for this decade only, unless otherwise noted.—